Kodak The Art of Digital Photography: Mood, Ambience & Dramatic Effects

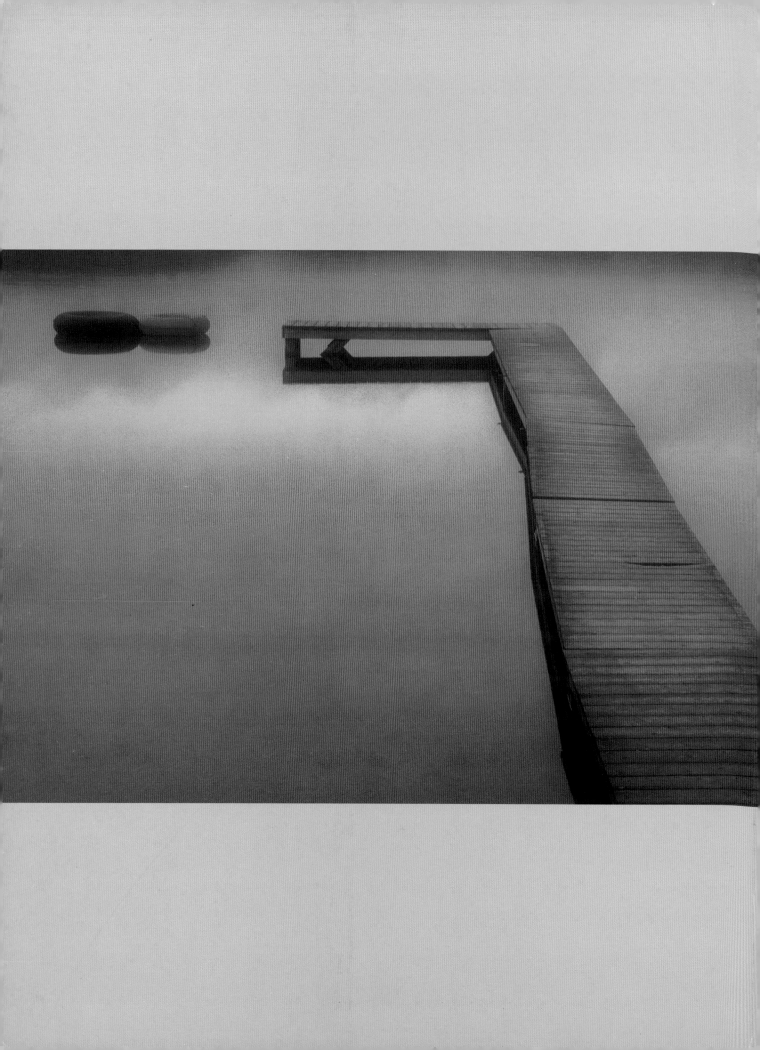

Kodak The Art of Digital Photography: Mood, Ambience & Dramatic Effects

Joseph Meehan

Published by Lark Books
A Division of Sterling Publishing Co., Inc.
New York / London

Editor: Haley Pritchard
Art Director: Tom Metcalf
Cover Designer: Thom Gaines
Associate Art Director: Lance Wille
Editorial Assistance: Cassie Moore and Mark Bloom

Library of Congress Cataloging-in-Publication Data

Meehan, Joseph R., 1940-
 Kodak : the art of digital photography : mood, ambience, & dramatic
effects / Joseph R. Meehan. — 1st ed.
 p. cm.
 Includes index.
 ISBN-13: 978-1-57990-970-3 (pb-with flaps : alk. paper)
 ISBN-10: 1-57990-970-1 (pb-with flaps : alk. paper)
 1. Photography—Digital techniques. I. Title. II. Title: Art of digital
photography.
 TR267.M43 2007
 775—dc22
 2007013523

10 9 8 7 6 5 4 3 2 1

First Edition

Published by Lark Books, A Division of
Sterling Publishing Co., Inc.
387 Park Avenue South, New York, N.Y. 10016

Text © 2008, Eastman Kodak Company
Photography © 2008, Joseph Meehan unless otherwise specified
Photography on pages 181 – 184 © Dan Burkholder
Photography on pages 185 – 189 © Theresa Airey

Distributed in Canada by Sterling Publishing,
c/o Canadian Manda Group, 165 Dufferin Street
Toronto, Ontario, Canada M6K 3H6

Distributed in the United Kingdom by GMC Distribution Services,
Castle Place, 166 High Street, Lewes, East Sussex, England BN7 1XU

Distributed in Australia by Capricorn Link (Australia) Pty Ltd.,
P.O. Box 704, Windsor, NSW 2756 Australia

If you have questions or comments about this book, please contact:
Lark Books
67 Broadway
Asheville, NC 28801
(828) 253-0467

Manufactured in China

ISBN 13: 978-1-57990-970-3
ISBN 10: 1-57990-970-1

For information about custom editions, special sales, premium and corporate purchases, please contact
Sterling Special Sales Department at 800-805-5489 or specialsales@sterlingpub.com.

 acknowledgements

I would like to thank Marti Saltzman of Lark Books for her original conceptualization of this book, and Haley Pritchard for her skillful editing of the final text.

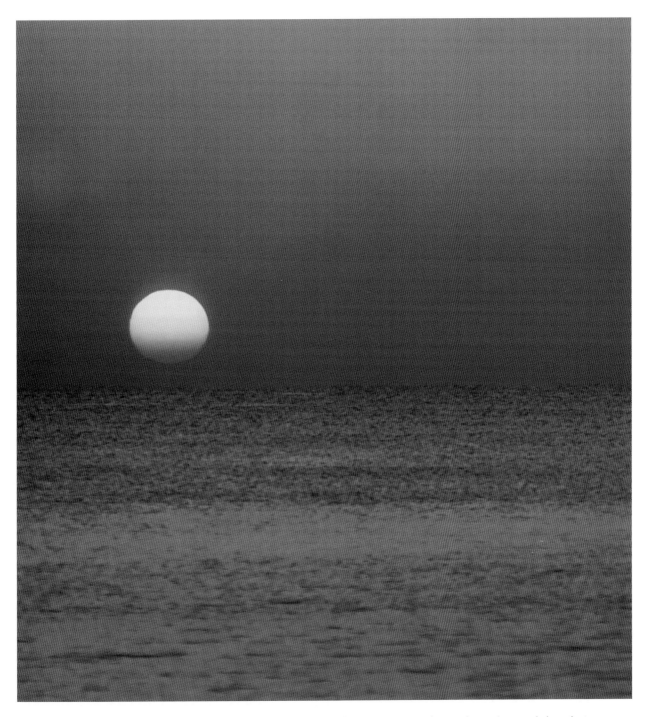

This book is dedicated to all photographers who struggle to represent their subject beyond the obvious.

contents

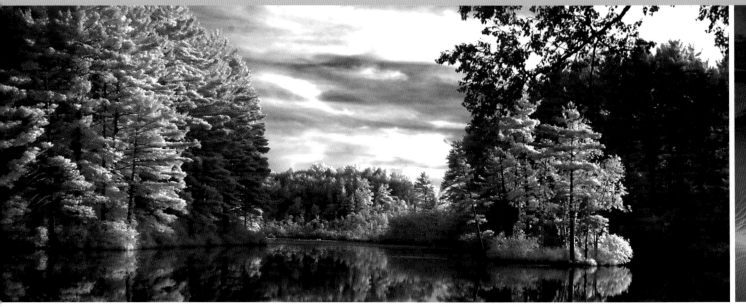

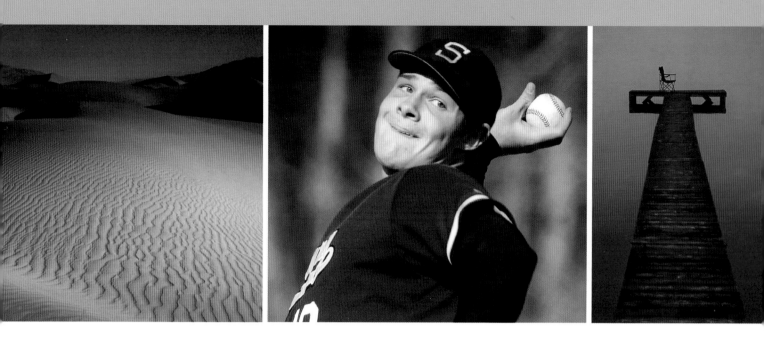

Photography as Personal Expression

1

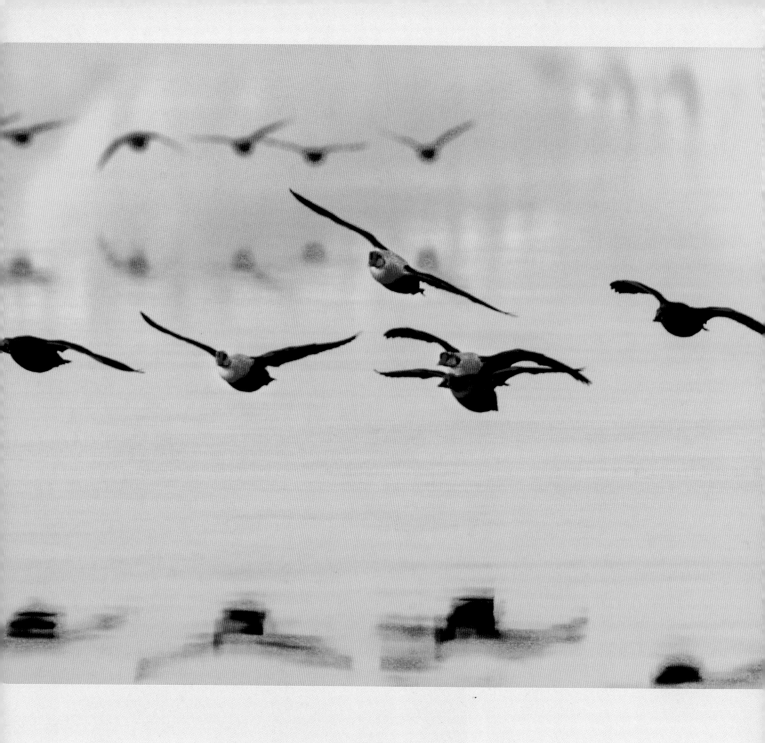

 "It is when the photographer chooses to push beyond the point of just documenting the subject that the real power of photography as a medium for personal expression begins to emerge."

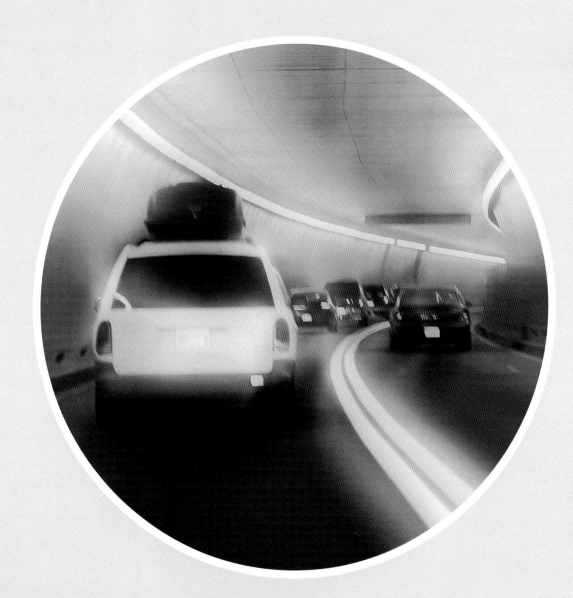

Call them winners, call them keepers, or just call them great photographs—they are the images that photographers strive to produce, the ones viewers will find appealing at the very least, if not fascinating or even emotionally moving. Sometimes these images will shock, amaze, or even produce a chuckle. They are often pictures that capture the subject in a different and creative way, perhaps revealing some hidden qualities in the process. These are also the images that make people take notice of the photographer because he or she has revealed something unique through the photograph. So, how does one produce such photographs that fulfill the aspirations of the photographer while catching and holding the attention of the viewer?

There are certainly several possible answers to this question. For example, just photographing interesting subject matter, such as famous people or places, assures at least initial interest on the part of the viewer. Then there are those images that fall into the category of newsmakers, as with catastrophes or pictures of strange and unusual phenomena. The fact is, however, that most photographers deal with everyday subjects, settings, and events. So, the more useful question to ask is: How does one make such everyday subject matter more interesting?

Choosing to interpret rather than just record a subject is a process that can emerge from any number of approaches. For example, deciding to emphasize some visual characteristic while playing down all others, as in the way successful portrait photographers accentuate the positive features of their subjects while mitigating negative ones, for example. Or, how a landscape photographer will return to the same location many times seeking just the right light to capture a particular ambience; a fleeting moment of extraordinary light and weather conditions that most people miss in their daily routine. Then there are all those situations in which the subject is captured in a very dramatic fashion using, for example, a combination of unusual camera perspectives, extremely fast or slow shutter speeds, or extra long or short lens focal lengths. This is often done in street photography, as well as when photographing sports and in photojournalism where the dramatic rendering is a much sought-after quality.

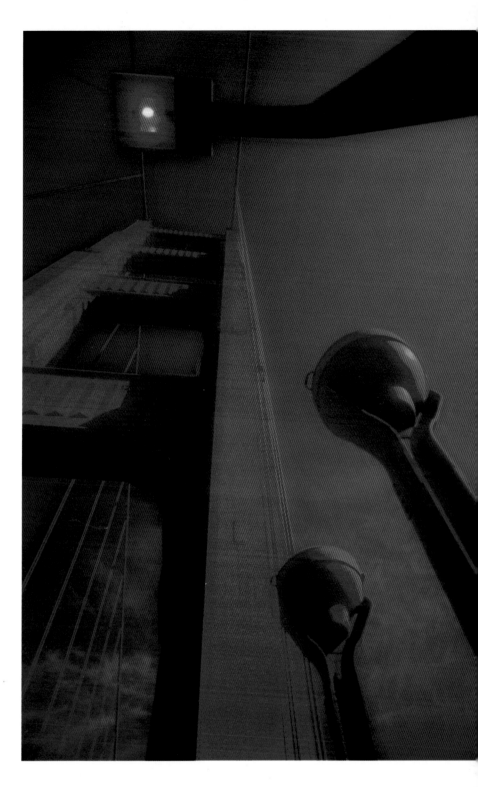

Once you've decided how you want to interpret a subject, there is also the question of degree. That is, the range between a subtle to a more extreme treatment of your interpretation, and all points in between. For example, it may be as simple as favoring a camera perspective that is slightly different from conventional portraiture, practicing with unusual props, or shooting from low angles with an extreme wide-angle lens. It may be the difference between a rather ordinary photograph of a group of flowers in a vase versus an extreme close up of the interior parts of that flower disclosing details not discernable to the unaided eye. Then of course, in addition to the photographic technique you apply to your interpretation of the subject, there are seemingly endless effects offered by various software programs that can further alter the appearance of a subject to suit your artistic vision.

About This Book

The purpose of this book is to present a cross-section of methods used by creative photographers who strive to present their subjects in a fashion beyond the ordinary. Through understanding the tools provided by the digital camera as well as the basic qualities of light, you present yourself with an enormous range of opportunities for artistic expression and personal interpretation. Each chapter herein also contains some examples of the selective use of different software techniques to finalize the image. All methods are illustrated with examples and key picture taking data. Portfolio sections at the end of the chapters apply the chapter material and further illustrate the techniques described. The appendix contains additional reference materials for techniques and software mentioned throughout the book. Finally, while the emphasis is on images captured with digital cameras, there are also some examples of film originals that have been scanned into the computer to reflect this approach to digital photography.

"*In addition to the photographic technique you apply to your interpretation of the subject, there are seemingly endless effects offered by various software programs that can further alter the appearance of a subject to suit your artistic vision.*"

This introductory chapter begins by considering some of the implications of interpreting the subject, as well as presenting you with and defining key terms that will be used throughout this book. In particular, we will explore just what is meant by mood, ambience, and dramatic effect as three primary ways of producing an extraordinary photograph. The second chapter focuses on the most basic ingredient in any photograph: light, and how the qualities of light are so critical to establishing mood, ambience and drama in an image. As the chapters progresses, we will take a look at how the tools and techniques offered by a digital camera not only capture this light, but also give the photographer extensive choices and controls for further shaping and refining the results. We will consider the panoramic option as a unique alternative to the conventional image, cover the role of weather and its impact on natural light, and finally, we will delve into the strange and strikingly unique world of infrared photography. At the end of the book, I will share with you a glimpse into the personal vision and motivations of two photographers who have followed their own creative paths, Dan Burkholder and Theresa Airey.

Implications of the Interpretive Approach

Choosing to explore an interpretive approach to photography is closely linked to what is usually thought of as a photographer's "personal style." A photographer's preference for the mechanical aspects of photography and the way they are employed will certainly affect the appearance of a subject, and a sense of that photographer's individual style is a consequence of the particular combination of photographic tools and techniques employed. Today's digital photographer has access to an impressive range of tools and techniques that would surely make early photographers of the last century envious.

No doubt about it, digital techniques have greatly extended the power of photography to make visual statements about people, places, things, and events. In fact, the choices today are extensive if not seemingly endless. I want to be clear, though, that the emphasis on interpretive photography outlined here is not meant to degrade the traditionally realistic documentary approach to recording a subject. On the contrary, it takes a high level of skill to capture a subject as realistically as possible. Everyday, thousands of photographers, amateur and professional, fine art and commercial, set out to make a representation of their subject as close to reality as possible. When successful, these images are typically quite striking in their visual accuracy, high level of photographic skill, and attention to detail.

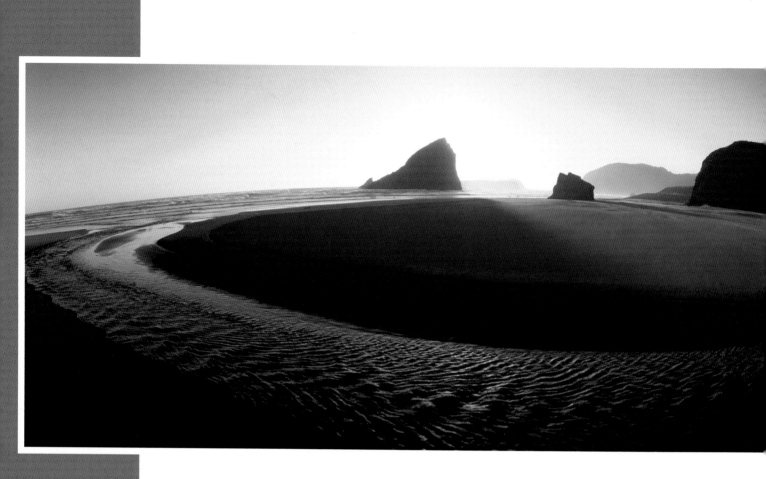

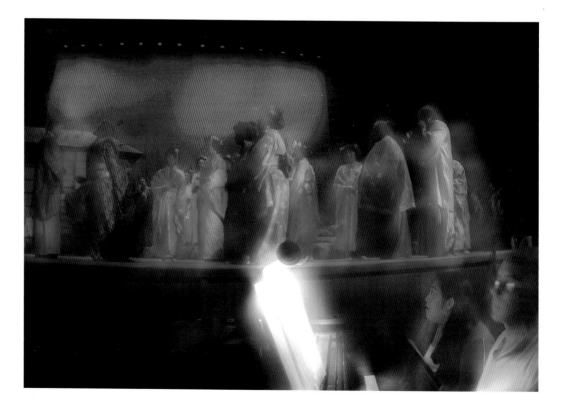

On the other hand, it is when the photographer chooses to push beyond the point of just documenting the subject that the real power of photography as a medium for personal expression begins to emerge. This requires a willingness to try new techniques and approaches. When this effort is successful, the viewer sees the subject in, literally, a new light. Hopefully, this conveys another level of appreciation of that subject, setting, or event, as well as recognition of the style, insights, and skill of the photographer.

So where and when does this drive to move beyond pure documentation of a subject happen for a photographer? Is it a sudden flash of recognition like being struck by a lightning bolt of creativity? Sad to say, the answer is most probably no. Rather, the path is more likely to follow the view of Thomas Edison who observed that great achievements are 10% inspiration and 90% perspiration, to which might be added a willingness to take chances and deviate from one's usual practices. Indeed, successful images are more likely to emerge as you

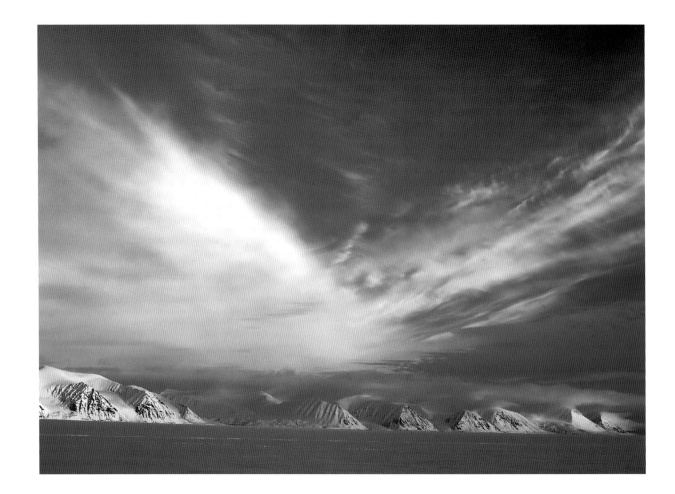

accumulate skill and experience with the tools and techniques of digital photography while developing a personal photographic vision of the world. To be sure, there are disappointments and dead ends along the way, but as the saying goes: nothing ventured, nothing gained.

For most photographers, the first step in moving towards new and different ways of rendering your subject lies in learning more about the craft of digital photography and honing specific skills. This skill level is paired with a willingness to take chances and to try something new. A dichotomy emerges between having to discipline oneself to learn the step-by-step specifics of the craft of digital photography while taking a more

free-wheeling approach to photographic technique to try for new outcomes. This can be challenging; you may feel torn between the security of staying with hard-earned, tried and true methods versus taking chances with something different. For many of you, however, the joy that inevitably results from trying new methods will be its own reward. Push the boundaries of digital photography and imaging. Use your personal feelings or impressions about the subject and try to find a way to have the photograph reflect those feelings. What is your sense of the subject's personality, and how might that be represented visually? Do you want to convey a sense of mystery about a certain place, or work with themes such as the "beauty of sport" or "the raw power of nature"? Apply those trusty hard-earned skills to explore new paths of personal expression.

This has always been the nature of creativity in the arts. One only has to consider the years it took so many now famous painters to learn their craft before they could apply those skills to portray the world uniquely through their art. The result was often something that challenged what the conventional art world considered acceptable. Similarly, the work of some of today's most progressive digital photographers has certainly stirred controversy among photographic traditionalists.

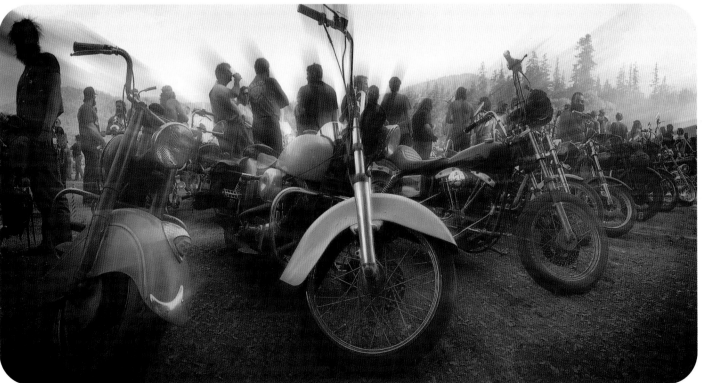

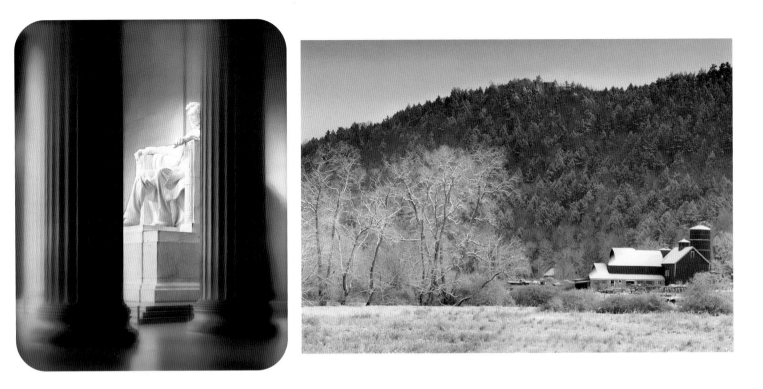

Defining Mood, Ambience, and Dramatic Effect

The terms, mood, ambience, and dramatic effect were selected for use in the title of this book because they are so often associated with extraordinary photographs. Simply stated, mood refers to a state of being or emotion, while ambience describes the atmosphere associated with a place or setting. Thus, a photograph that conveys a sense of mood will have an emotional quality or feeling to it, such as serenity, joy, anger, fear, or foreboding. These moods can be conveyed photographically in a number of different ways. For example, by a subject's expression, the use of bright versus dreary colors, heavy shadows versus bright settings, and so forth. Ambience, on the other hand, will tend to manifest itself more generally, such as through all encompassing qualities like color rendering (warm versus cool color temperatures), the hardness or softness of a light source, or the use of a soft focus filter, for example. And certainly, there are times when mood and ambience merge to create an effect on the viewer.

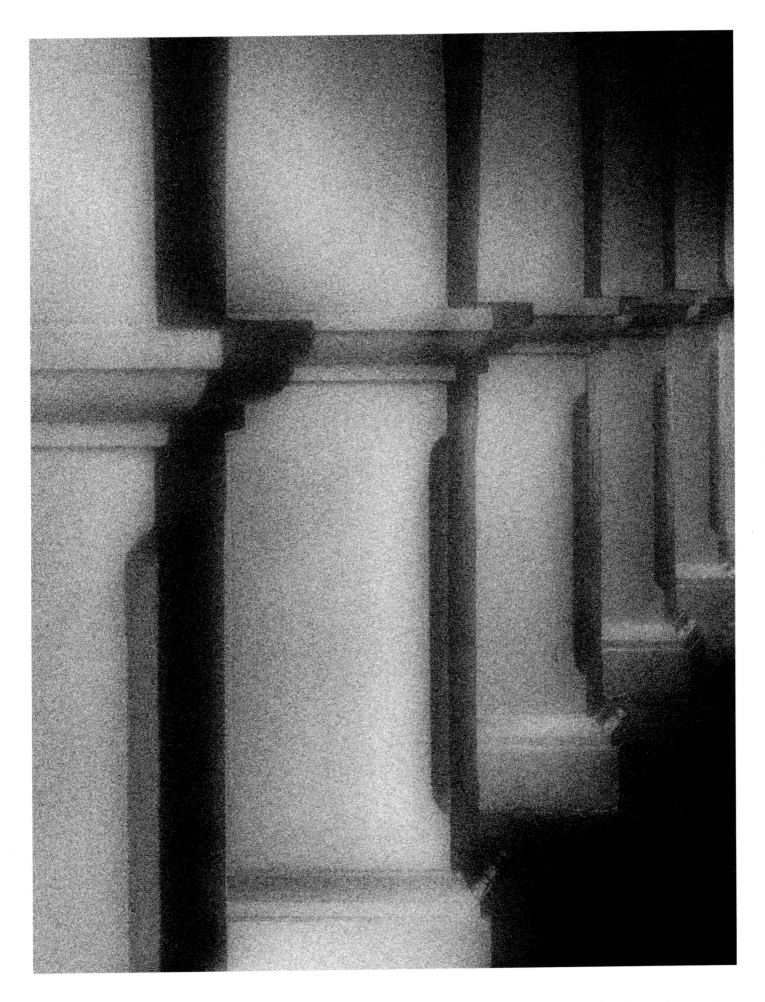

Photography as Personal Expression 25

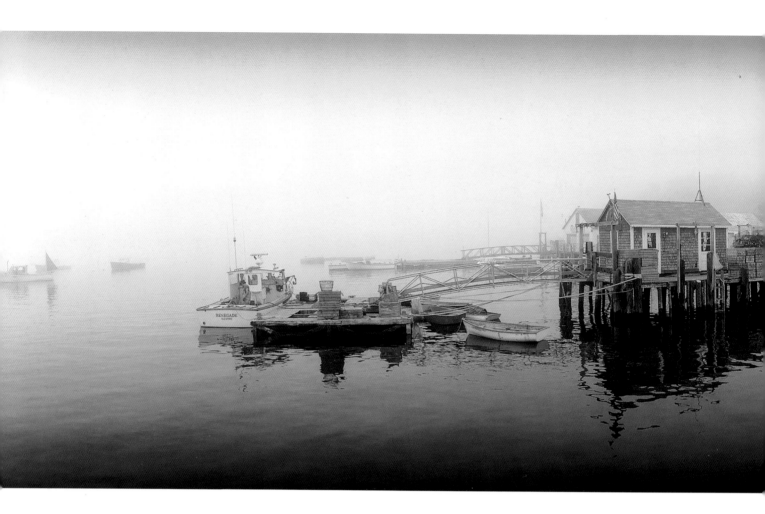

Dramatic effect in a photo is often expressed as something that is bold or striking in appearance; something that is attention grabbing or even riveting. Such results are obtained using a wide range of tools and techniques, such as extreme camera angles, very long or short focal length lenses, and extremely slow or fast shutter speeds. And, of course, the subject matter itself can be a tool for dramatic effect; the intense beauty or hardship found in peoples faces, or a scene from a war or natural disaster all have profound effects on the viewer.

The term "photographic tools" refers to all the hardware and software associated with digital photography. At the camera level, this includes aperture and shutter speed selection, lens focal length, white balance, ISO sensitivity, camera filters, and whatever means are being used to produce and/or control light, such as flash, light diffusers or reflectors, and various software controls. In the case of software, the tools can be as utilitarian as general color corrections and contrast adjustments on up to more extensive treatments that significantly alter the look of the image. "Photographic technique" refers to how these tools are used, such as in the selection of a specific camera perspective, final framing of the subject, or the elements of composition.

> *"As with all creative expression, the final result will be unique to the artist."*

In summary, the selection of a specific tool or technique is analogous to the painter selecting the size and shape of the canvas as well as the colors, specific brushes, and types of strokes that will be used. But as with all creative expression, the final result will be unique to the artist. For example, asking four different world famous photographers to photograph the same subject will certainly result in four very different photographs. Why? Because each photographer has their own unique idea of how he or she wishes to portray a subject or scene. In addition, different photographers also favor different tools and techniques for producing their final impression.

Developing one's own approach to photography requires serious effort on the part of the photographer. On the other hand, many will be content with just copying a particular style that is dependent on certain camera or computer techniques. It is, however, the willingness to pursue one's own vision that has the greatest potential to produce something that is far more personally rewarding. This is the most important implication of taking the interpretive approach to photography.

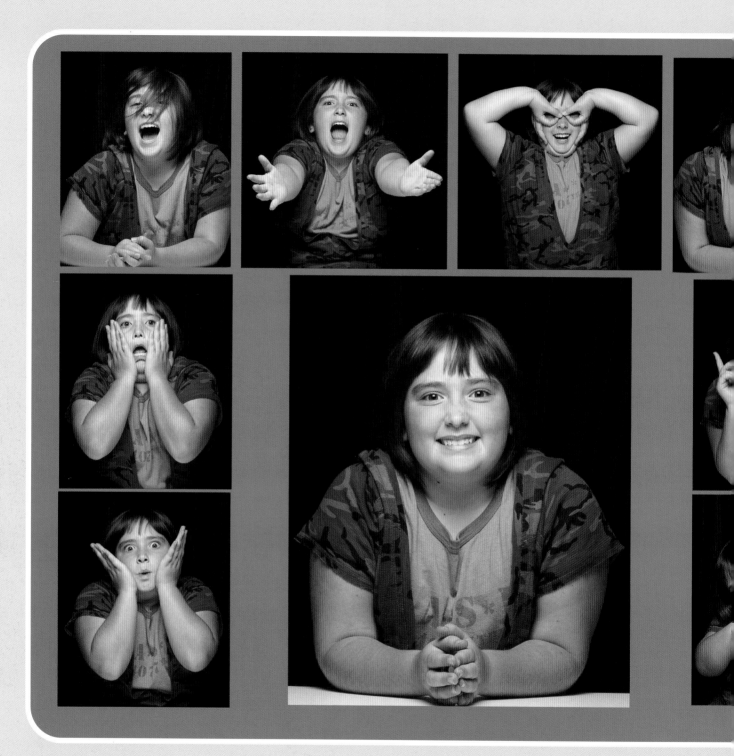

Portfolio:
The Personality Portrait

Characteristically, children are brimming over with energy that is so often expressed through facial expressions and body language. It is impossible to capture all these expressions in a single photograph. So, why not do a series of pictures?

The individual poses of this bubbly 10-year old were captured using a studio soft box set directly over the camera in front of the subject and a 105mm lens on a digital SLR. The instructions were simple. I described a situation and asked the subject to act out the emotion. For example: "You are surprised! You are happy! You are sad! You feel like kidding around! Make a face, any face!" The result is a series of expressions that tell much more about this vivacious young girl than one single photograph could.

2

The Qualities of Light

Light is the medium that makes photography possible, in all its natural and artificial variations. In the vast majority of cases, light is captured on the camera's sensor as it reflects off of different surfaces. The quality of the light source and its direction can render the appearance of a subject in a myriad of ways, as seen in the examples throughout this book. In the case of natural light, the characteristics can also be altered significantly as it passes through natural light modifiers like clouds, fog, and rain.

Photographers have many terms to describe light sources (hard light, medium light, soft light, sidelight, backlight, warm light, low-key, high-key, etc.). Basically, these descriptive terms are referring to one or more of light's four basic qualities: color properties, level of contrast, direction relative to the subject, and brightness intensity. Understanding the dynamics of these four qualities and their impact on key camera functions as covered in the next three chapters is essential information for the creative photographer. Accordingly, this chapter explores how these four qualities combine to offer a wide range of opportunities for producing a sense of mood and ambience as well as plenty of opportunities for dramatic effects. Later in the book, we will also explore how weather conditions further modify natural light presenting even more variations for the creative photographer (see pages 148 – 167).

The Color of Light

Natural light, electronic flash, and studio rated tungsten are the most common light sources used in photography. All are composed of three primary wavelengths: red, green and blue (RGB). These are referred to as the additive primaries because all other colors in the spectrum are the result of different proportional mixes of these three primary colors. If the proportions of these three wavelengths are at or very near equal (33.33% each), then the light is considered neutral for photographic purposes and referred to as "white light," or simply a "neutral source." If a white light source were projected on a pure white wall, its surface would appear as pure white to the human eye as well as any camera whose

The Color Composition of Light

Light Source	Kelvin Temperatures (Range)	Wavelengths **		
		(R)	(G)	(B)
Sunlight* & Strobe:	5,400 – 6,000K	33	33	33
Sunrise/set:	2,800 – 3,000K	55	30	15
Overcast:	6,000 – 8,000K	27	34	39
Blue Sky:	10,000 – 15,000K	17	34	49
Studio Tungsten Lighting (Type B):	3200 or 3400K	50	30	20
Average Household Tungsten Lighting:	2500 – 3000K	61	32	7

*4 hours after sunrise/before sunset

** Percentages (approximate)

white balance were set to record such a source, such as the Sunlight and Flash (or similarly named) white balance settings on a digital camera. These settings are appropriate since both the sun and electronic flash are close to having an equal balance between the three primary wavelengths, naturally making them neutral light sources.

If the proportions of the three primary wavelengths shift, the source will lose its neutrality and develop a colorcast. This is important to take note of because mood and ambience are very much related to the presence of colorcasts. In the case of the common photographic light

sources, this shift is primarily between red and blue wavelengths, with green remaining relatively constant (see The Color Composition of Light chart on page 33). This is the basis of labeling a light source as either "warm" or "cool" versus neutral. Using the Kelvin scale, a rating of 5,400 to 5,600 degrees Kelvin is generally considered a neutral source. Higher ratings would indicate a shift towards the "cooler" (bluer) portion of the color spectrum and lower numbers indicate a shift towards the "warmer" (redder) end of the spectrum. However, these generalizations do not apply to all light sources. For example, mercury vapor and sodium vapor outdoor lighting do not contain a complete RGB color spectrum, and commercial fluorescent lighting contains a green spike in its spectrum.

It is also possible to pick up a colorcast as light reflects off of colored surfaces before reaching the camera. For example, a light green colorcast in the shadow areas of a bride's white dress caused by a photographer's flash bouncing off light green walls. The principle involved is subtractive filtration, in which a colored surface will reflect its colors in a light source while absorbing all others to a degree based on the density of the color. Thus, in our example, the light green wall absorbed some blue and red from the white light of the flash while reflecting all or most of the green. In practical application, the amount of green reflected would depend on how close to "true green" the paint pigments were. This is also how color camera filters produce their effects, with the amount of absorption dependent on the density of the color in the filters.

The warm light of sunrise and sunset is yet another example of an imbalance between the red and blue ends of the spectrum. For most of the day, sunlight is a neutral source, but during sunset and sunrise, as well as just before sunset and just after sunrise, sunlight becomes decidedly warm. In this case, the effect has to do with a scattering of wavelengths. Specifically, the low angle of the sun means the light has to travel through a larger mass of atmosphere as opposed to when it is overhead. Blue wavelengths are scattered to a much greater degree, revealing the red end of the spectrum in greater proportions. On the other hand, when clouds block the sun during the day, the cooler wavelengths of reflected light from a blue sky will add a blue cast. Likewise, when the sun is below the horizon, as in at dusk and dawn, cooler wavelengths dominate.

The point at which the human eye can detect the appearance of a colorcast will vary from person to person but, in general, a color is usually detected first in neutral gray or white areas (such as the bride's dress example mentioned earlier). A color meter is the most accurate way of measuring the color content of a light source. Significant differences in color temperature can be adjusted for by using the appropriate selection in the digital camera's white balance feature, or by making a correction later in the computer. Many photographers will routinely tweak color balance in the computer, especially if the purpose is to record neutral areas completely free of colorcasts.

The Influential Power of Color

References to how colors can influence mood and ambience abound in popular literature. Such phrases as "he turned red with anger" or "a blue melancholy mood" make an obvious link between color and emotion. There also continues to be significant scientific and marketing research on this subject to guide color choices for a wide range of applications, including interior design, fashion, and product marketing, to name a few.

The low angle of light from a sunset streaking through the woods along with the use of a soft focus filter combine to give this scene a definite sense of warmth. A similar impression is dominant in the lake setting in example (b). In this case, I added warmth to the scene by applying a warm software filter at its maximum intensity.

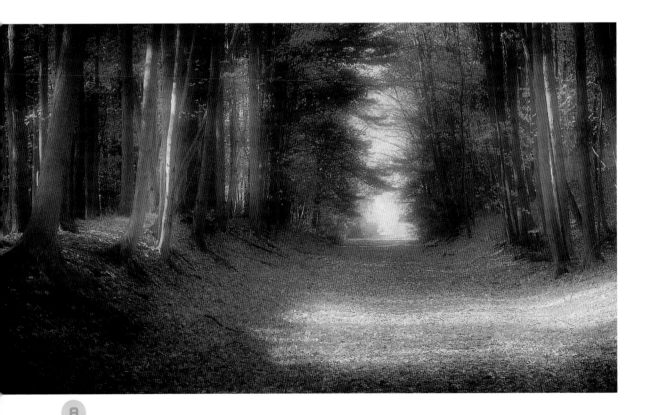

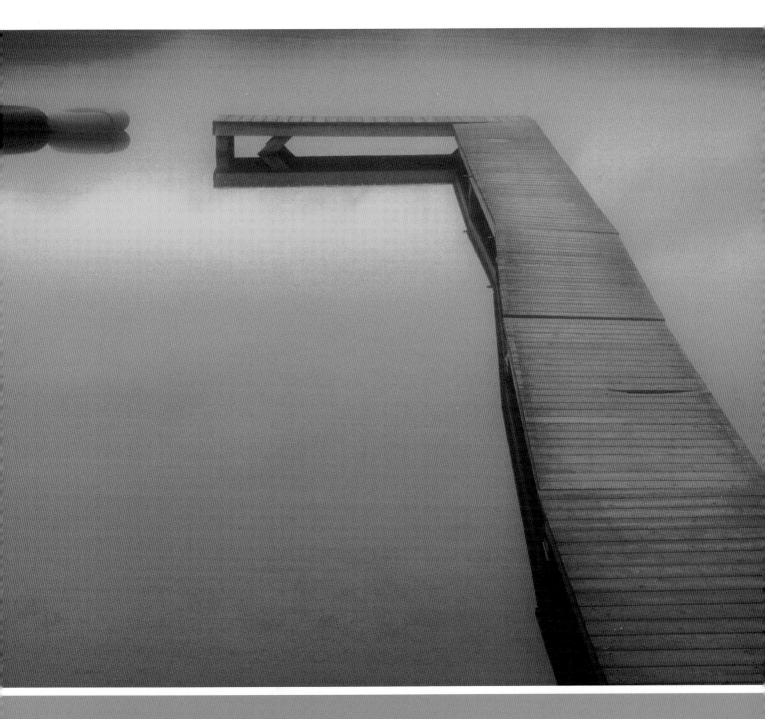

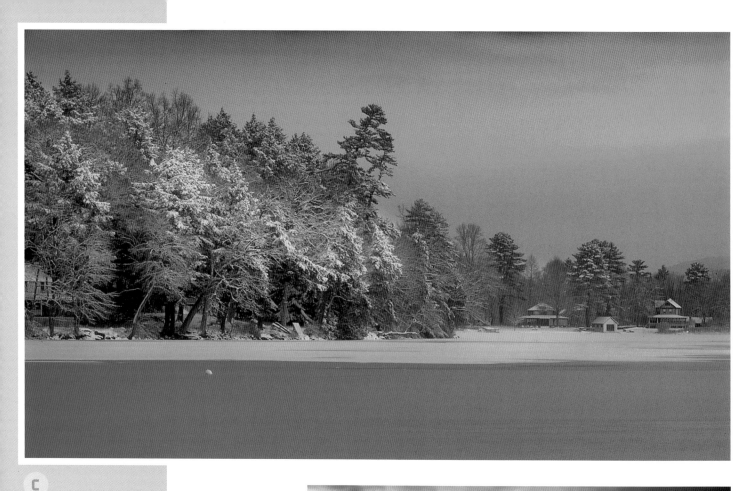

C

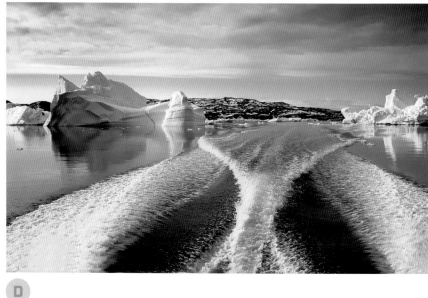

D

Moving in the other direction, let's contrast the warmth of the first two examples here with the gloomy mood of a gray, overcast day, or the icy blue of a snowy landscape. In example (c), the setting now conveys a cold ambience during the dawn light of a very cold and still winter's morning. In example (d), the slight blue colorcast results from using a daylight white balance to record this cloudy scene. People's reactions are so tied to warm and cool colors that you can be reasonably sure of evoking certain feelings with your image by implementing the use of a strong colorcast.

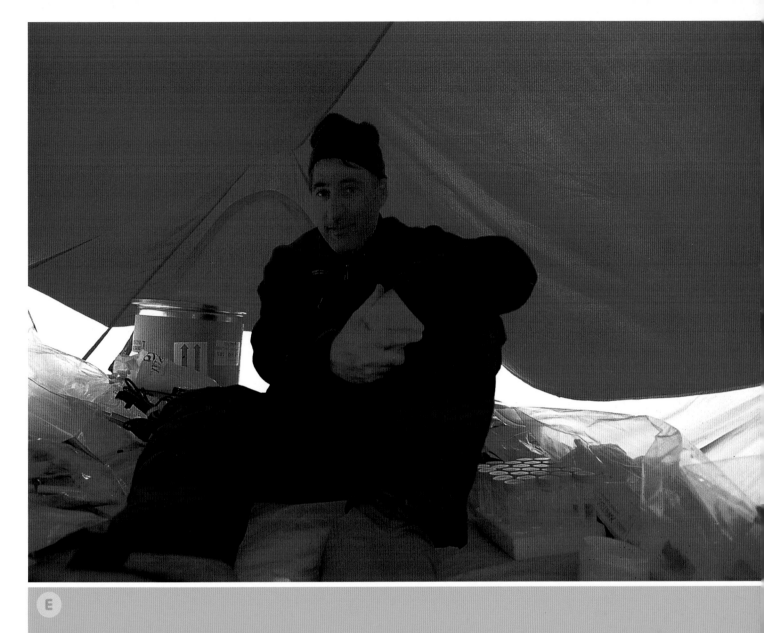

E

There are also times when a very slight shift in the color content of a light source can introduce a subtle shift in mood or ambience. It is for this reason that nature and portrait film photographers have long favored the use of weak warming filters such as the 81A or 81B. With digital cameras, these effects can be produced using the white balance feature or in the computer with image-processing software. There are also times when unusual environmental conditions will produce a strong color shift, as in the scene inside the red tent in example (e). In this case, the deep red color of the tent absorbed virtually all other colors, allowing only red to pass through, and thus demonstrating the process of subtractive filtration.

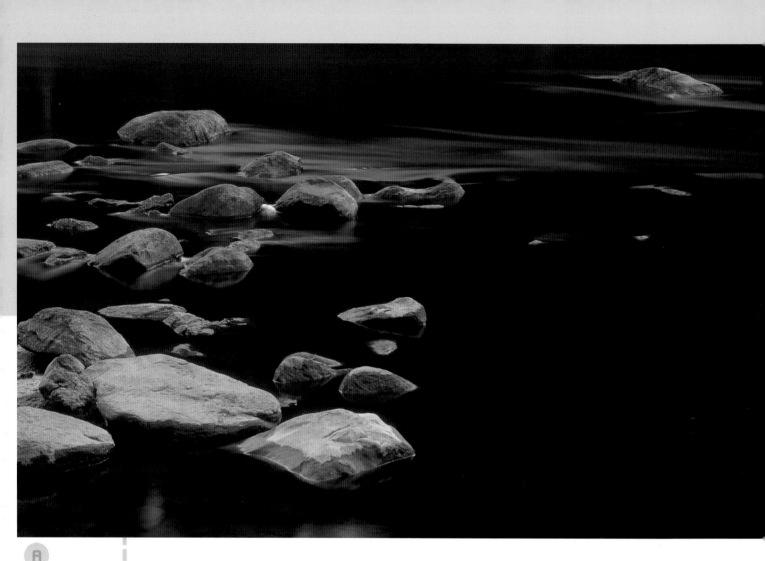

Contrast and Lighting

I n general terms, photographic contrast refers to the difference between the brightest highlights and darkest shadow areas that have been recorded with discernable details. This difference is commonly expressed in f/stops. For example, an image with just a two-stop difference would have a low contrast appearance, while a five-stop difference would represent a full range of contrast. This difference can be seen immediately in the histogram of the digital camera or later in the histogram of an image-processing program. A full contrast scene would produce a curve with data distributed throughout most of the recording, whereas a low contrast scene would have the data bunched up in one section of the curve.

B

"Low-key" and "high-key" are two additional terms that are important to be aware of. They are used to describe the kind of light that is falling on a subject or scene and are based on the preponderance of shadow and highlight areas respectively. Low-key lighting emphasizes shadow and other darker areas. Think of the kind of lighting you would see in the movie genre "film noir", with deep dark shadows often obscuring parts of the subject, tending to support a mysterious, foreboding, even sinister ambience, as seen in examples (a) and (b), both taken on heavy overcast days. The strong blue colorcast in example (a) is the result of the high Kelvin temperature of the overcast day and dominant shadow areas and in the case of example (b), the use of

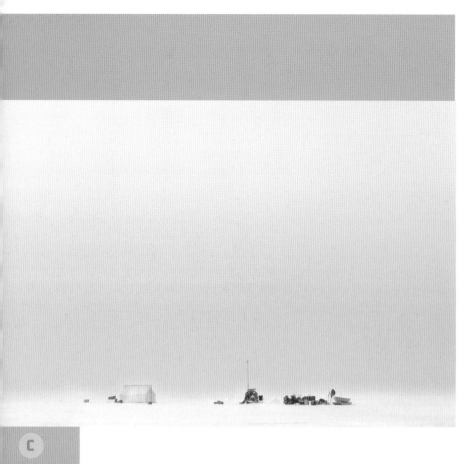

a blue 80a software filter effect. High-key refers to a situation in which the scene is dominated by highlight areas with some middle tones and very few if any shadow areas. This sort of lighting supports "light and bright" moods or an airy ambience. For example, the white on white snow encampment in example (c), taken in bright sunshine softened by a heavy mist, or the still life of white pearls in example (d), captured with an on-camera soft filter.

Expressions in Contrast

Photographers are generally concerned with capturing details in the brightest highlights and darkest shadow areas in addition to a full range of midtones. The basic reason for this is obvious. If parts of the scene are under- or overexposed, then some of the visual information about the picture is lost to the viewer. Typically, in straight documentary photography, the goal is to capture all the possible visual information across a full contrast range in order to present as complete and accurate a picture as possible. For example, photographing small products for a catalogue or portraits for identification purposes. This is the reason that a medium contrast light source is often selected in the studio or outdoors.

If you want to render the subject differently, however, you can use contrast in a number of ways to achieve various effects. Shooting in low contrast light, such as on an overcast day, can reinforce a number of different moods in the composition, from somber, to gloomy, to sad. Photographing a subject in silhouette is an option that purposely renders shadow areas with minimum detail or completely black. The reduction in visual information about the subject is fertile ground for a poignantly mysterious ambience. Conversely, photographing under high contrast sunlight will often support a bright and cheery mood, as in children playing in bright sunshine or the sparkle of sunlight off of a lake on a summer afternoon. Some of these options are illustrated in The Power of Shadow Light portfolio section at the end of this chapter (see pages 50 – 55).

In addition to using "high-key" and "low-key" to describe the lighting in a scene or image, the terms "soft light" and "hard light" are also used to convey the potential emotional impact of different levels of contrast. The soft light produced by a very large soft box in a typical studio portrait produces weak shadows with gradual transitions to midtones and highlight areas. The

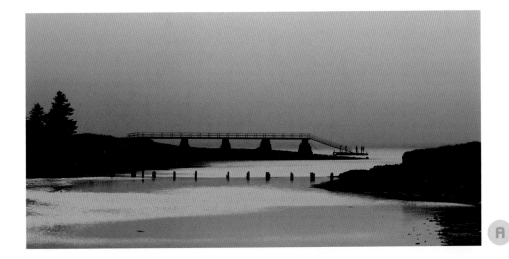

A

B

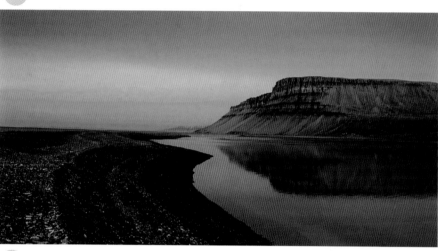

C

D

High Dynamic Range Photography

High Dynamic Range photography (HDR) has recently garnered a degree of attention in the world of digital photography. HDR uses different approaches to capture a much wider range of light values from shadows to highlights as compared to what has typically been possible with digital cameras. Advances in digital technology are enabling manufacturers to move towards producing new cameras that will be capable of capturing a much wider dynamic range of light. Currently, however, HDR photos can be accomplished in the computer using image-processing software to combine multiple images, each of which have captured part of the full range of light values so that, when combined, the final image offers the full dynamic range, as seen in the image above. Another example of HDR photography is included in the portfolio section featuring the work of photographer Dan Burkholder (see page 184).

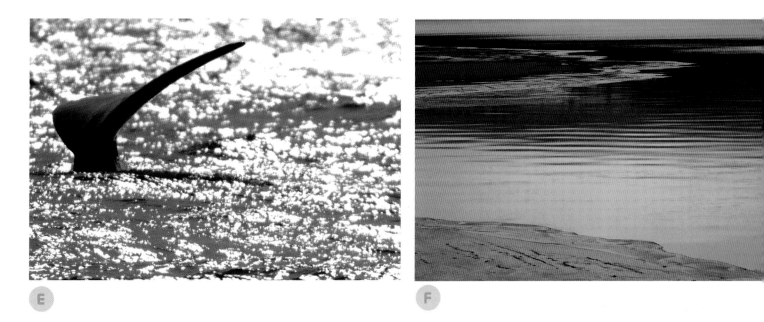

E F

result is a very gentle rendering of the subject's features. Natural light conditions such as fog, snow, mist, the subdued light at dusk, and even the haze of pollution will act as giant diffusers, producing results such as those seen in examples (a – on page 43), (b), (c), and (d). High-contrast hard light is characterized by deep, dark shadow areas with sharply defined edges and overexposed highlights, as in example (e) where bright midday sunshine is reflecting off the water, and example (f) where the direct light of a setting sun is striking the water and ice surfaces. Such lighting is often appropriate for dramatic rendering of people, as in the case of a rock band or a prizefighter.

Contrast can be controlled, or at least affected, in a number of different ways. Many digital cameras will provide a mode or internal menu option to record a scene with more or less contrast. Contrast adjustment is also a common feature of many image-processing programs. In the case of natural light, contrast is initially controlled by the sun and weather, then by the efforts of the photographer. Common methods of altering natural light contrast include using fill light or a light diffuser, two techniques that are also employed extensively by studio photographers. Effective fill light in the form of a reflector or a burst of flash will brighten dark shadow areas so that more details are recorded. A diffuser, on the other hand, enlarges the size of the source light, which has the effect of lowering the contrast range in the same way that a soft box enlarges the light of a studio strobe. For the creative purposes, however, using more extreme contrast in a scene usually produces the most dramatic effects.

Light Direction for Dramatic Renderings

The placement of a light source relative to the position of the subject will control where shadow areas fall both on the subject's surface and in the background and/or foreground. In the case of front lighting, the source is placed as close to the lens axis as possible, producing minimum shadow size. This position is least favorable for displaying textures. It is, however, much preferred as a beauty light since it is does not emphasize the texture and flaws of the skin. Conversely, side lighting emphasizes textures and is more likely to produce a dramatic, high-contrast rendering, especially if a small source is used. This position may require the use of fill light to bring up some shadow detail while still maintaining the dramatic look.

Placing the light behind the subject (backlighting) is a situation that raises certain problems in terms of exposure. That is, the subject is entirely in shadow formed by the light coming from behind. If the photographer wishes to maintain a lighting balance between the background and the backlit subject, a fill light must be used on the subject. The usual procedure is to add enough light to match (or be slightly less than) the background light depending on the look desired. If no fill light is used, then the exposure must be based on the weak light illuminating the front of the backlit subject. This will render the areas behind the subject overexposed, which can be one way to reduce the impact of busy backgrounds. Backlighting will usually produce some accent lighting around the subject's outline or on any subject surface turned slightly toward the direction of the backlight, such as the side of the face.

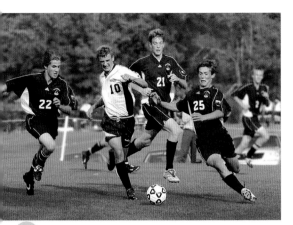

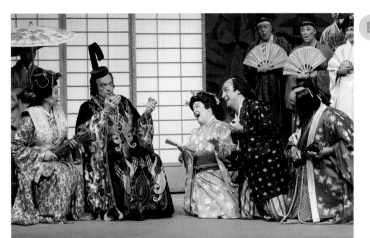

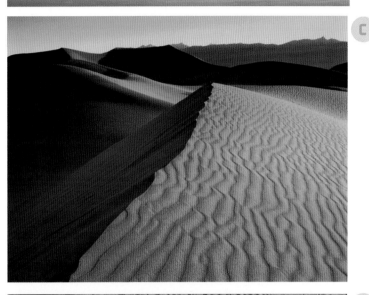

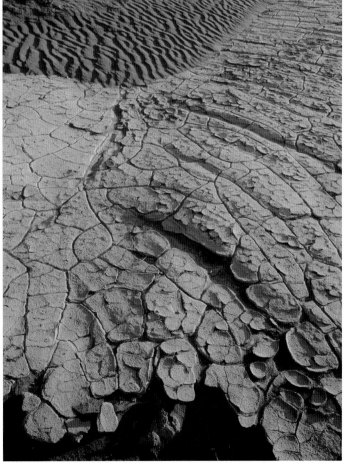

Examples of Directional Lighting

Front lighting is preferred for fully illuminating a subject, as seen in the faces of the soccer players vying for the ball in example (a). In example (b), front lighting from many smaller overlapping stage lights form a white light "wash" that evenly covers the stage. Even front lighting is often preferred in scenes when the whole stage is being used by a group of actors. This type of light is excellent for avoiding large shadow areas while fully rendering bright colors.

By comparison, side lighting is very effective at bringing out distinct shapes, contours and textures both large and small. In example (c), the direction of a warm sun just at the horizon to the right of the sand dune produces a dramatic rendering of both the texture of ripples in the sand as well as the larger shape of all the dunes. The same principle of side lighting for dramatic textures is shown in example (d), but this time in a closer perspective, bringing out small details in the dried mud.

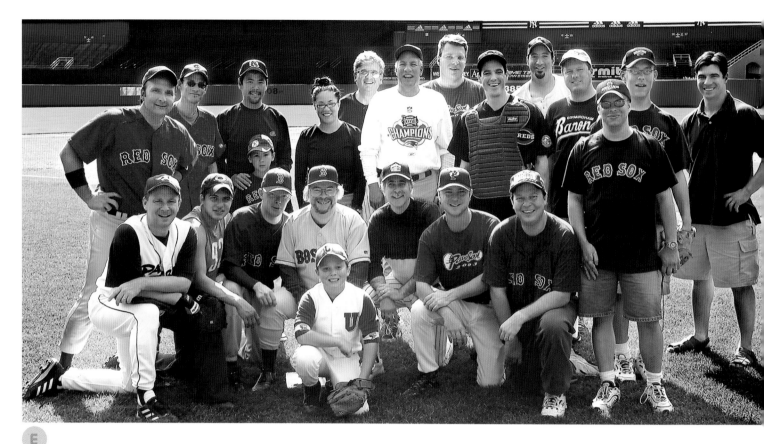

E

F

Backlighting may require a degree of fill light, as seen in example (e) where an on-camera flash supplied extra illumination to this group of baseball players. The amount of light was about 1/2 stop less than the light in the rest of the picture, adding a degree of sparkle to the smiling faces. In example (f) however, no fill light was used. Instead, the exposure was adjusted to the weaker light on the front of the subjects that was about three stops below the light in the room resulting in an overexposed, washed out background.

Light Intensity

ight intensity refers to how much light is available to take the picture. Typically, intensity is measured using either the camera's light meter or a handheld model. These readings are then expressed as a combination of aperture and shutter speed. The two main forms of light measurement are reflected light and incident light. That is, measuring the light reflected off of the subject versus measuring the incident light falling on the subject. These readings are then translated into a specific combination of f/stop and shutter speed settings to yield the desired exposure.

While the degree of light intensity is critical for determining exposure settings, knowledgeable photographers realize that the amount of light controls much more than just exposure. In particular, light intensity affects the range of possible choices in aperture and shutter speed settings. The selection of a particular aperture will determine the depth of field—how much of the picture will be in sharp focus. Shutter speed then determines how motion will be recorded in the image. Will you choose to stop motion with a fast shutter speed so that your subject appears sharp, or allow for creative motion blur with the use of a slower shutter speed? Aperture and shutter speed selections are powerful tools that can significantly affect how the subject and the overall scene will be portrayed. The next chapter explores the impact of these tools in detail.

Light Intensity and ISO

In addition to controlling choices in aperture and shutter speed, light intensity also influences the range of possible ISO settings you can use. With digital cameras, ISO sensitivity settings represent the sensor's relative sensitivity to light. The higher ISO setting you use, the greater the amplification of the sensor, and the more sensitively it will react to light in a given scene. As with film ISO ratings, the higher the ISO you select, the less light is needed to make a correct exposure. Digital noise and other artifacts, however, tend to become more noticeable at higher ISO settings. Consequently, the lowest ISO sensitivity yields the best digital image quality the camera is capable of delivering.

ISO selection also affects aperture and shutter speed choices. For example, the need for a fast shutter speed in low light situations requires a high ISO setting. Indoor sport arenas, theaters, and other artificially illuminated settings have lower levels of light intensity compared to a typical daylight scene so, if faster shutter speeds are needed to stop indoor action, ISO ratings of 400 or higher will be required.

Summary

The four qualities of light—color, contrast, direction, and intensity—combine to present you, the photographer, with a range of options to carry out your own personal interpretation of a subject or scene. The next step is to consider the specific camera tools and techniques available to help you achieve that interpretation. As you might imagine, these tools and techniques are integrally affected by the four qualities of light outlined in this chapter, so bear this information in mind as we move on to explore a variety of unique and exciting methodologies.

Portfolio: The Power of Shadow Light

The creative photographer knows the value of shadows for helping to define a subject and as a means for capturing many of that subject's physical qualities, such as shape and texture. Shadows are also a key ingredient for introducing a sense of drama and for portraying subjects in extraordinary ways. In this portfolio, the role of shadows will move from helping to define shapes and textures to serving as a supporting compositional element, and finally to forming the main subjects in a picture.

In the white on white snow scene in example (a), the lack of shadows on a heavy overcast day makes it difficult to see contours and shapes much less textures in this example of high-key lighting. The light produced by a lower sun in example (b), on the other hand, is ideal for producing definite shadow areas disclosing shapes and contours for a more dramatic rendering, added to by the strong color contrast of a deep blue sky from a polarizing filter. In example (c), the soft, layered textures of a slot canyon wall are appropriately

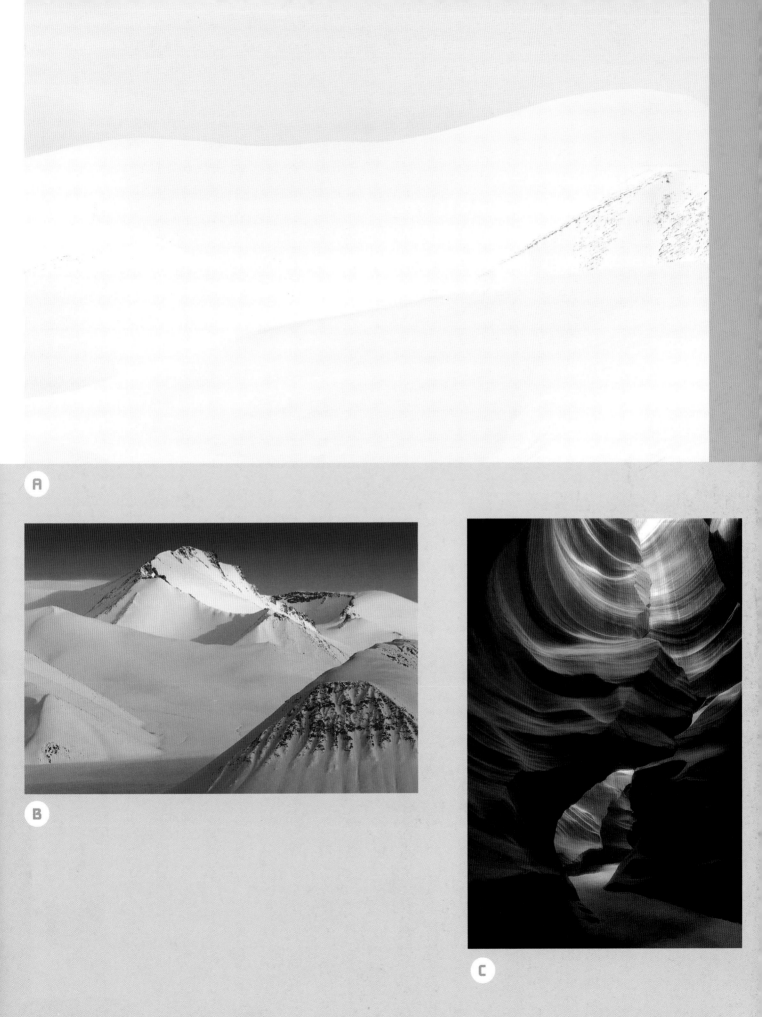

A

B

C

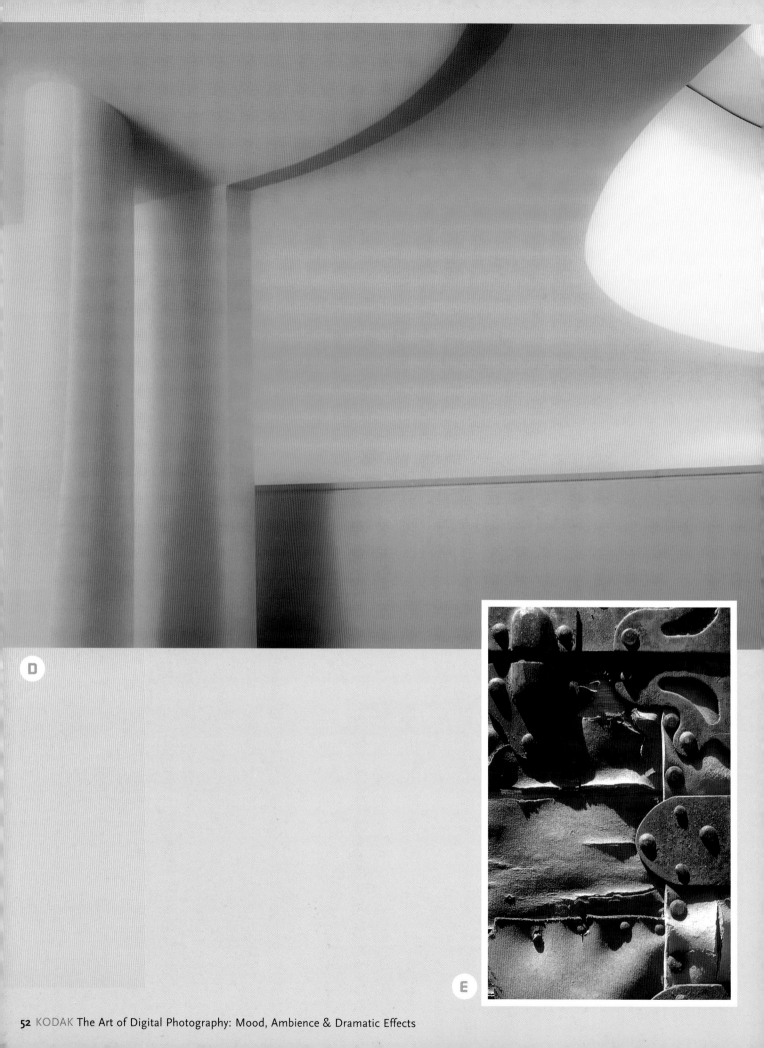

D

E

rendered with gradual transitions between shadows, midtones, and highlights by diffused medium contrast sunlight coming through a slightly overcast sky. This is also the role played by shadows in example (d), where the gradual transition between shadow and midtone areas helps convey the round shape of the interior building columns. On the other hand, in example (e), the harder shadows with sharply defined edges from direct overhead sunlight are more appropriate to bring out the rough character of an old leather trunk with rusted metal work.

In the next series of images, the shadow formations move beyond the role of defining shapes, contours, and textures, to become their own compositional element. This is the case in the desert landscape in example (f) where a good part of the foreground is composed of defining massive shadow areas. The distinctive shadow lines in

F

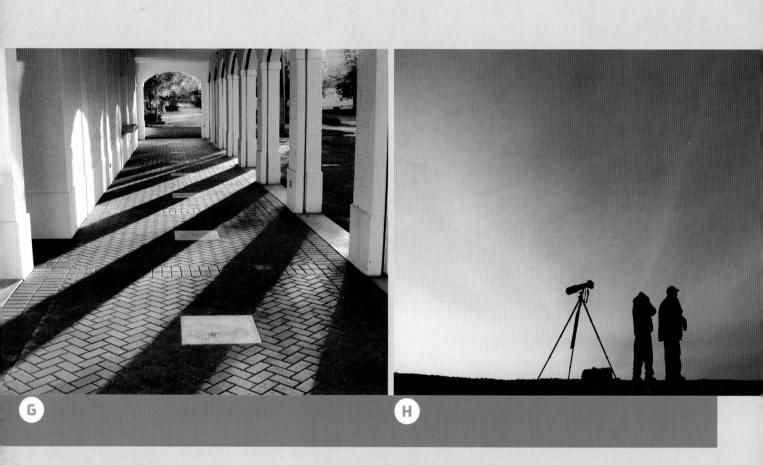

G

H

example (g) are the key compositional element, providing a dramatic statement of the power of shadows to reflect and extend the role of the upright supports from this low perspective in early morning direct sunlight.

The most basic form of shadow expression is the silhouette, in which the subject becomes entirely, or almost entirely, a shadow area. Exposure is based on rendering a main subject as dark and without much detail against a properly exposed background. In example (h), taken with a moderate wide-angle lens at a low perspective, the two people and camera on a tripod are outlined against a sky of weak afterglow light. In example (i), the exposure was again based on the weak light of an afterglow sky using a moderate tele-photo lens to slightly compress the space between the people, the horse in the fore-ground, and the person walking towards them. I also used a mist camera filter and made some adjustments using image-processing software to reduce some of the excessive orange warmth of the light. In example (j), the effect of rendering the main elements of the ice flows and the mountain with a 250mm focal length underexposed by one stop reduces these visual elements to have a graphic-like quality.

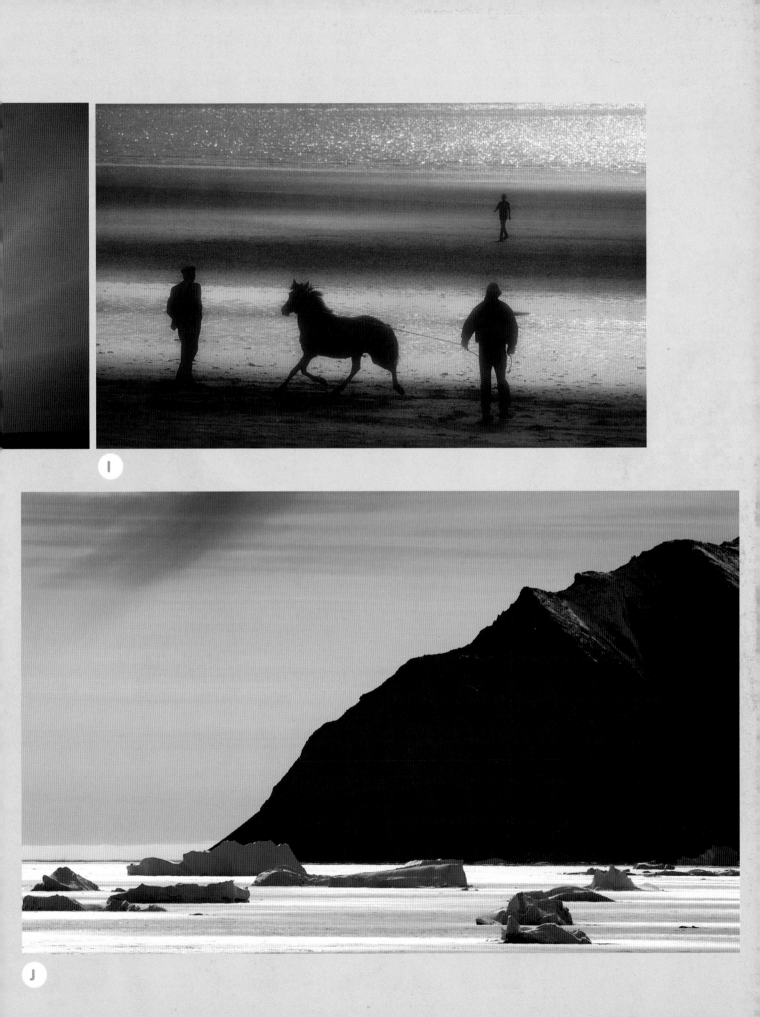

Aperture, Shutter Speed, and ISO Sensitivity

3

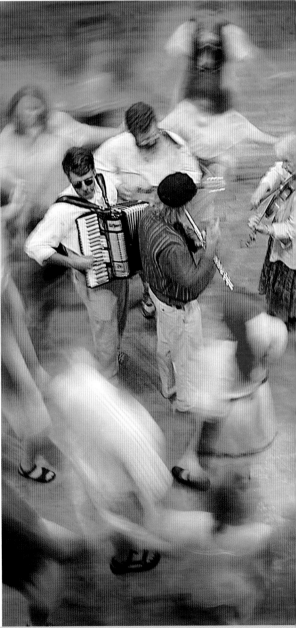

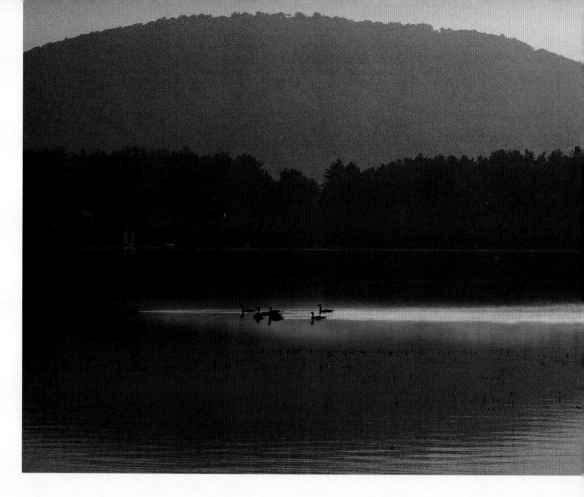

n today's world of automatic cameras and "fix-it-in-the-computer" photography, it is easy to overlook the ability of the most basic camera functions to control and significantly affect an image. Tools such as aperture, shutter speed, white balance, and ISO can singly or in combination provide the creative photographer with plenty of opportunity for personal interpretation and expression. Today's all-automatic camera functions are a relatively recent development. For most of the history of photography, photographers operated in an all-manual fashion, first measuring the light and calculating an exposure based on the ISO of the film, then manually setting aperture and shutter speed and perhaps correcting for a filter factor. As a consequence, they were familiar with not only the exposure results of these selections, but also their specific and unique pictorial impact. The photographer who relies exclusively on the completely automatic modes of today's cameras will not easily gain this same intimate knowledge of how basic camera tools control the final image.

Even with a plethora of automatic functions at your fingertips, you still have options for using this automation in such a way that you the photographer, not the camera's computer, are in ultimate control. This approach combines the best of modern digital camera technology with your creative skills. The tools and techniques in question are aperture, shutter speed, white balance, ISO sensitivity, lens focal length, camera perspective, and camera filter selection. Each of these has both a primary function to control the overall photographic quality of the image along with secondary effects that offer opportunities for creative photographic expression. In this chapter, we will concentrate on the creative potential of aperture, shutter speed, and ISO sensitivity.

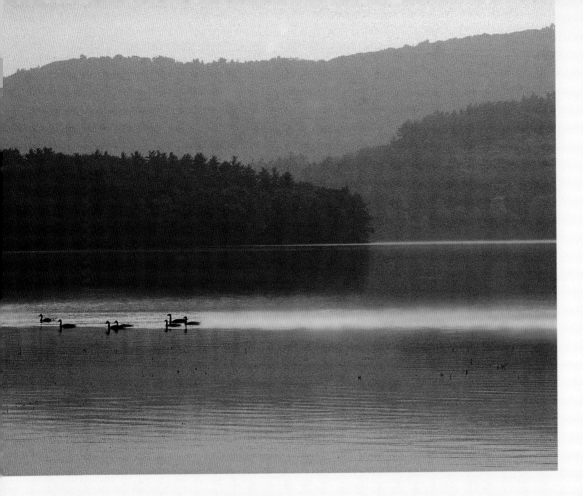

The primary function of the lens aperture and its f/stop settings is to control how much light passes through the lens to reach the sensor. Each f/stop setting represents a different size aperture opening as indicated by logarithmic values (f/2.8, f/5.6, f/8, f/11, f/16, etc.). Aperture is one of the three camera functions that directly controls exposure. The other two are shutter speed, which determines the amount of time the sensor is exposed to light, and ISO sensitivity setting, which raises or lowers the amplification of the sensor to change the way it reacts to the light (effectively making it more or less light sensitive). Each of these controls can change the amount of exposure in the same proportional amount relative to each other. That is, widening your aperture by one full f/stop will increase the amount of light reaching the sensor in the same way that reducing the shutter speed by one half will. For example, going from f/11 to f/8 increases the amount of light by one stop, as does going from 1/125 second to 1/60 second, or from 1/30 to 1/15 second. By the same token, doubling the ISO number, such as going from 100 to 200, or 800 to 1600, will increase the sensor's relative sensitivity by the equivalent of one stop. Conversely, halving the ISO number, such as going from 400 to 200, will lower the sensor's relative sensitivity by the equivalent of one stop.

Beyond Exposure Control

While aperture settings are critical to obtaining correct exposure, it is the way in which the size of the aperture opening also controls depth of field that gives photographers an important tool for controlling the appearance of the subject and setting. Depth of field is defined as that area in front of and behind the point of focus that is considered acceptably sharp. As the aperture opening becomes smaller, the size of the area in sharp focus becomes larger. As a result, more and more of the scene that falls in front of and behind the point of focus is sharp. Conversely, as the aperture opening becomes larger, the depth of field area of sharp focus becomes smaller and smaller. Depending on what parts of the scene you wish to emphasize, controlling depth of field can help you to achieve your goals (see pages 62 – 67 for more information).

The photographer can exert direct control over aperture selection by using one of two camera modes: (a) the all-manual mode in which both aperture and shutter speed have to be dialed in, or (b) the aperture priority mode where the user sets the aperture and the camera then controls the shutter speed selection to produce a correct exposure. The remaining two common auto camera modes, shutter priority and program mode, both turn control of the aperture selection over to the camera's computer. In shutter priority, the photographer locks in the shutter speed and the camera alters the aperture for a correct exposure. This is the choice when the object is to keep the shutter speed constant for various shutter speed effects (see pages 70 – 76 for details). In program mode, the camera controls both shutter speed and aperture for a correct exposure. Thus, the photographer has no direct control over aperture or shutter speed.

Aperture and Depth of Field

The visual impact that depth of field can give to an image can be quite significant, making it a powerful tool for the creative photographer. If you choose to maximize depth of field by using a small aperture opening, a larger area of the scene will be in acceptable focus, and the more likely that the various visual elements will be integrated. That is, the viewer will see a scene that has the same level of acuity and, thus, will sense a unity between the image elements. The classic example is the landscape that shows everything from near foreground to far background in sharp focus using typical "deep" depth of field settings such as f/11, f/16, and f/22. This reinforces the feeling that everything is part of a single landscape.

Using a shallow depth of field, on the other hand, where just the main subject is in-focus, produces a sense of isolation between the sharply focused subject and the out-of-focus background and foreground. This is because, as the viewer scans a picture, the eye is drawn to those parts of the image that are in-focus and recognizable as opposed to those areas that are out-of-focus and less easily recognized. The classic example is the action sport shot in which the sharply focused players are isolated from spectators or other distractions in the background by using a wide aperture opening such as f/1.4 or f/2.8.

As mentioned in the first chapter, the degree to which a technique is applied is an important consideration. This is particularly true with depth of field techniques, where the amount that the background and/or foreground is thrown out of focus is a flexible rather than an absolute quantity. That is, these areas do not have to be always completely out of focus. As a result, the isolation of the subject can vary from subtle to extreme. For example, when the background is just slightly out of focus, it can be perceived to be a secondary area associated with the subject adding another visual layer to the picture. Throwing backgrounds just slightly out of focus can also add the illusion of depth to a scene since objects further away will be recognizable but somewhat out of focus. In the case of a completely out of focus background, the isolation of the subject is more complete and the background loses any detail, serving more as a blank slate to allow all emphasis to rest on the sharply focused subject.

Using Depth of Field for Pictorial Effects

As we've learned, the amount of depth of field in a photograph will significantly affect the way individual visual elements are perceived. If everything is in focus due to a smaller aperture opening—such as in image (a), shot at f/11-16, or image (b), shot at f/22—there is a tendency to see all visual elements as unified parts of a whole composition. Also, visual clues, such as leading lines from foreground to background, are at their greatest impact when they are in sharp focus, as in the wheat field featured in image (b).

On the other hand, if a very large aperture opening is used, then the resulting shallow depth of field will allow for the total isolation of a subject as typically seen in sports photography, such as in image (c), taken at f/2.8, or with everyday subjects such as the playful young boy in

A

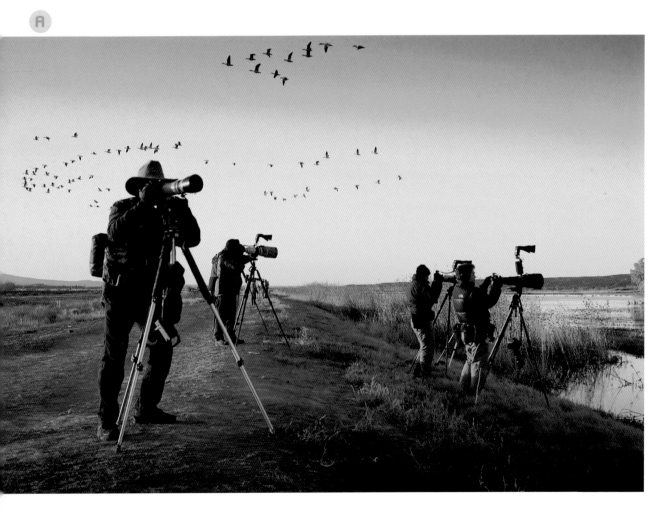

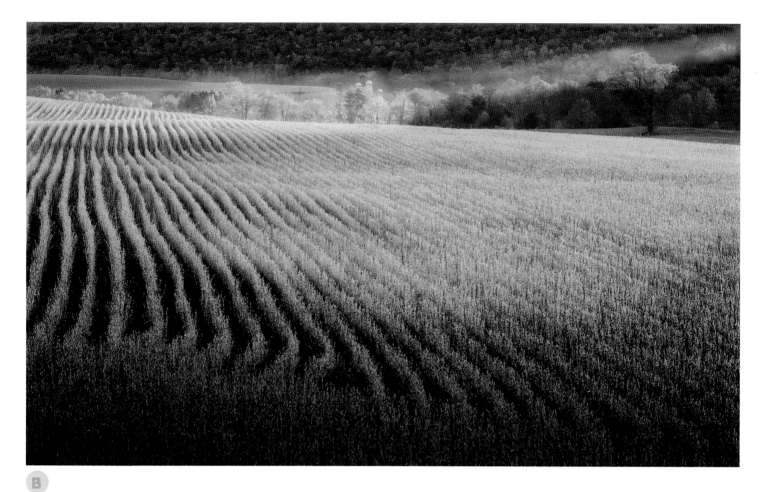

B

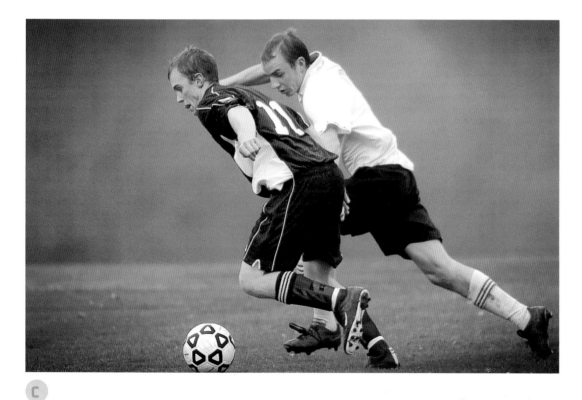

C

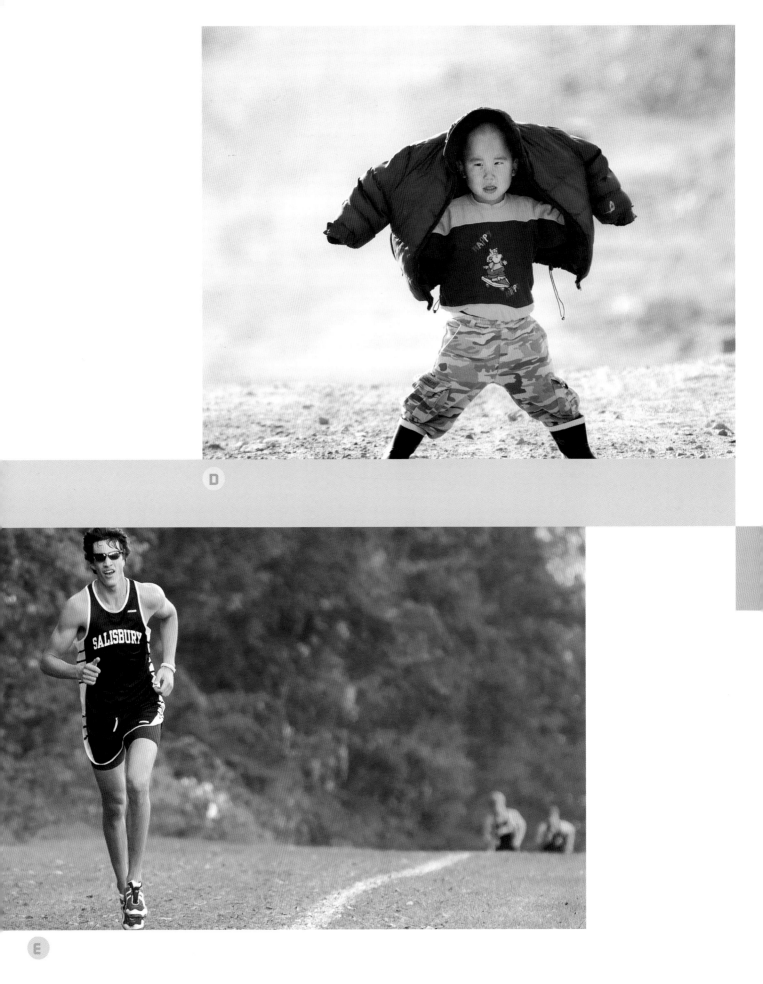

D

E

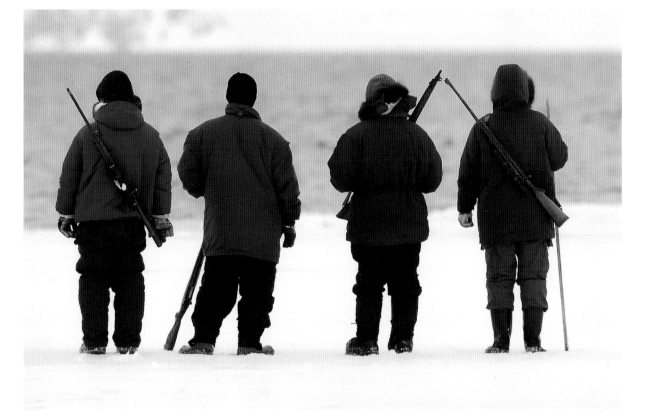

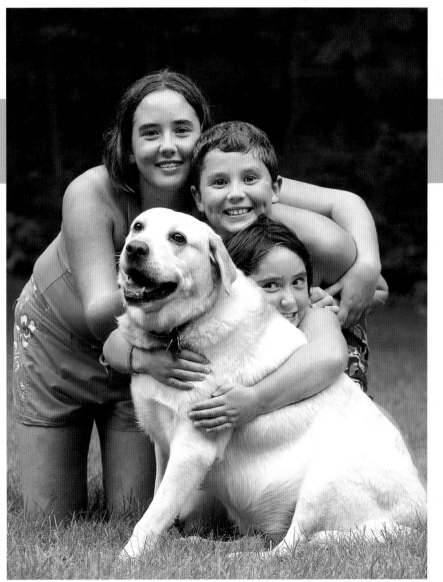

image (d), taken at f/4.0. This isolation, however, does not have to be from completely blurred areas around the subject. It is often helpful to have the background just discernable enough to support and give a context to the sharply focused subjects. This is the case with the cross-country runner in front of the other runners in example (e), taken at f/5.6 with a 250mm focal length, and the arctic hunters framed against the water and mountains in example (f), taken at f/6.7 with a 400mm lens. The faint outline of the trees in the background of example (g), taken at f/5.6, is enough to suggest a general outdoor setting for the three young people and their pet dog.

H

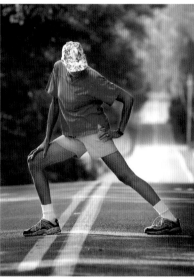

I

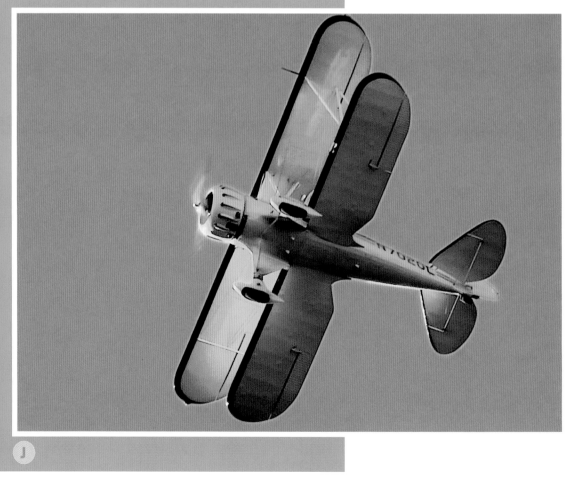

J

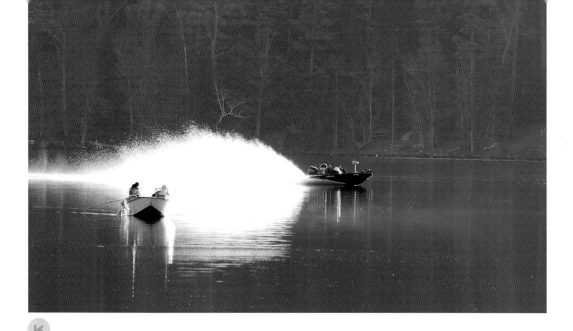

K

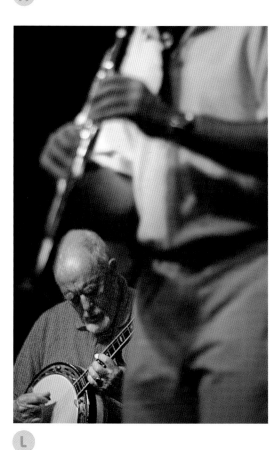

L

Compare this to example (h), where an aperture of f/8 produces a sharply focused and specific background of snow making it perfect for a winter holiday greeting card. A shallow depth of field can also support the illusion of depth, as with the roadway behind the jogger appearing just slightly out of focus in example (i), taken at f/5.6-8.

A subject can also be isolated entirely by selecting a plain background, as in the case of the airplane against a clear blue sky in image (j), taken at f/11 with a 400mm lens, or the speedboats against a dark, tree-lined shore in image (k), taken at f/11-16 with a 250mm focal length. And remember, the out-of-focus section of the picture does not always have to occur behind the subject. Throwing the foreground out-of-focus can sometimes produce interesting framing within the image to support the subject. This is the case with the banjo player and a nearby saxophone player in the foreground in example (l), taken at f/2.0 with a 85mm lens.

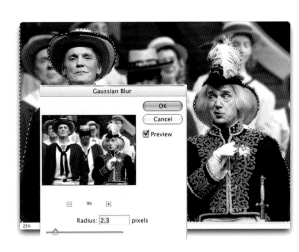

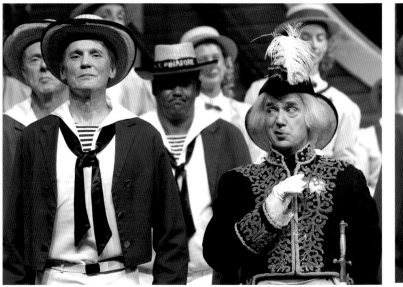

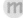

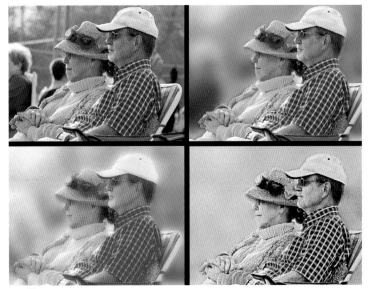

Software Alternatives

The most common software method for throwing a background and/or foreground out of focus to help isolate a subject is to use a blur tool to lower the sharpness of these surrounding areas, as illustrated in image (m). Once a busy background is removed, additional software effects may be applied, further isolating the main subjects. In example (n), photographer Natalia Stork has captured her parents in a wonderful moment but with a somewhat busy background (top left frame). The subjects were selected and the busy background blurred using the same technique as with the stage actors (top right frame). To reinforce the feeling of serenity and the detached nature of the moment, a black-and-white filter effect was applied to the image in the bottom right frame. In the bottom left frame, different color filter effects were used.

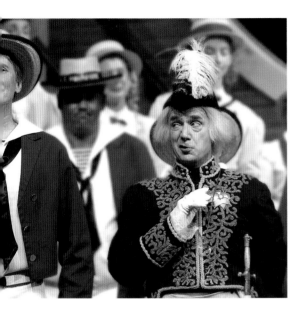

The Lensbabies Accessory Alternative

It is also possible to alter depth of field through the use of the Lensbabies camera accessory designed to alter the place of focus using movements similar to a view camera (a). Image (b) shows the amount of depth of field from a f/5.6 aperture with the Lensbabies accessory in the normal position. Image (c) shows the significant decrease in depth of field caused by a tilting of the lens using the same f/5.6 aperture. The amount of change can be controlled from a minimum decrease to the large amount shown, all without altering the aperture. Aperture disk inserts shown in (a) provide for a range of f/stop choices (www.lensbabies.com).

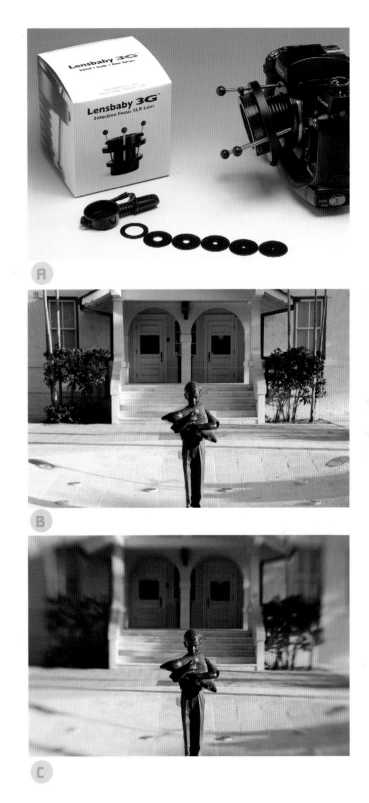

The Visual Impact of Shutter Speed

As pointed out earlier, selection of shutter speed is based initially on exposure considerations. The secondary role of shutter speed then comes down to deciding how motion will be recorded within a correctly exposed image. Usually, a shutter speed is selected based on trying to reproduce the subject in sharp focus. In other words, a shutter speed that is fast enough to prevent any blurring from the movement of a handheld camera and/or the subject's motion. The rule of thumb practiced for years by 35mm film photographers wanting to avoid blurred pictures from camera movement is to use the shutter speed closest to the reciprocal of the lens focal length. For example, using a 50mm lens would require a minimum shutter speed of 1/60 second; a 105mm lens would require 1/125 second; a 200mm lens would require 1/250 second, and so on. This approach can also serve as a guideline for digital photographers. Of course, all of this is very dependent on how steady the photographer can hold the camera. Some lenses and camera bodies include vibration reduction mechanisms that can allow for handholding the camera at shutter speeds slower than you would be able to otherwise.

In the case of subject movement, the variables are the speed and the direction of movement relative to the camera. In general, higher shutter speeds are required to freeze the action when the subject is moving perpendicular to the camera's position. Thus, a shutter speed just fast enough to render a static subject sharp will not be fast enough to prevent the blurring of a subject moving even slowly in a perpendicular direction to the camera, or even towards the camera.

Shutter speed selection will depend on whether or not the photographer is holding the camera still or following the moving subject. That is, in a "follow focusing" or "pan focus" movement, the camera moves with the subject. If this technique is used with a relatively slow shutter speed, the background and foreground will blur as streaks while the subject will appear reasonably sharp. The sidebar on the following page contains more information and recommendations about movement and shutter speed selections when the purpose is to blur movement. Still another option is to use a combination of flash with a slow shutter speed in a panning motion. The result is a razor sharp subject and a blurred background.

Suggested Shutter Speed Settings for Motion Blur Effects

* 1/15 to 1/4 second—for slow movement, such as a person walking, a slow jogger, or slow moving cars

* 1/10 to 1/20 second—for moderate movement, such as sports players or runners at a track meet

* 1/15 to 1/30 second—for fast movement, such as bicyclists and cars on city streets

* 1/30 to 1/60 second—for extremely fast movement, such as the swing of a tennis racket, baseball bat, or golf club

For the creative photographer, selecting a shutter speed is often bound up with the concept of conveying the illusion of time as a function of motion. This is especially true with slower shutter speeds, in which the blurring of a subject is perceived as movement and also the passage of time. Typically, a sharp photograph of a moving subject shows that subject has been captured in one place in time, but when a blur pattern is produced, the subject is actually being recorded taking up space at several places over time within the blur pattern.

At the other end of the spectrum, we have the effect of freezing a fast moving subject with a fast shutter speed such as 1/250 second, 1/500 second, 1/1000 second, or even faster. What makes such images extraordinary is that they reveal the segment of a movement that is happening so quickly that the viewer does not normally see the action. Thus, fast shutter speeds reveal a segment of time and reality too fast for normal perception. Again, as with the slow shutter speed application, the same conditions apply. That is, a faster speed is required of a subject moving perpendicular to the camera.

Both the blur action and freeze action techniques offer many opportunities for producing an extraordinary image. The portfolio, "The Many Moods of Water," at the end of this chapter is based on the creative application of these principles.

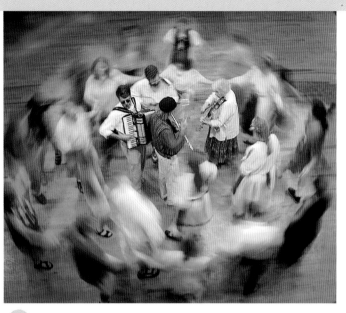

A

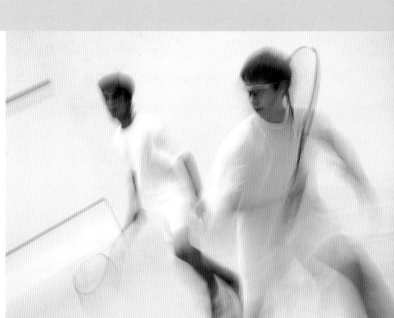

B

Creating Motion with Slow Shutter Speeds

Blur patterns produced by slow shutter speeds support the illusion of motion as well as record-ing time in a single frame. When very slow speeds are used, the image can take on an abstract quality. In example (a), a slow shutter speed of 1/5 second from a high perspective produced a strong circular blur pattern because of the quick motion of the dancers circling the stationary musicians. In example (b), the blurred movements of both squash players, shot at 1/10 second, show a number of different degrees of blur as they move their arms and legs at different relative speeds. There is also some camera movement, as well, at these slow shutter speeds. In example (c), the drive to the basket has been captured at 1/5 second using a panning action producing an abstract rendering. In example (d), another drive to the basket has been captured while the zoom ring on a 35-70mm lens was moved quickly during the 1/5-second exposure. In example (e), taken at 1/8 second, the motion of the women runners is almost directly toward the cam-era, while in example (f), the soccer players are moving perpendicular to the camera and have been caught in a follow focus movement at 1/20 second.

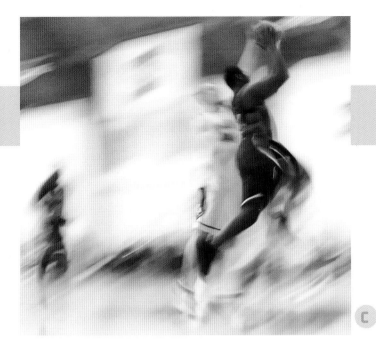

C

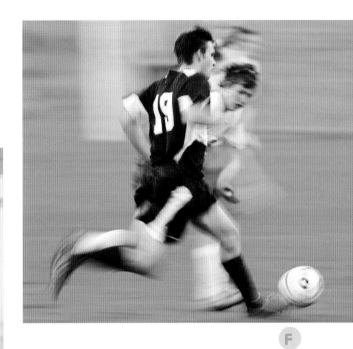

F

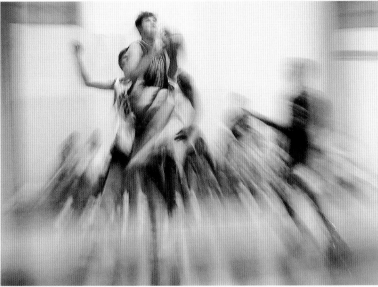

D

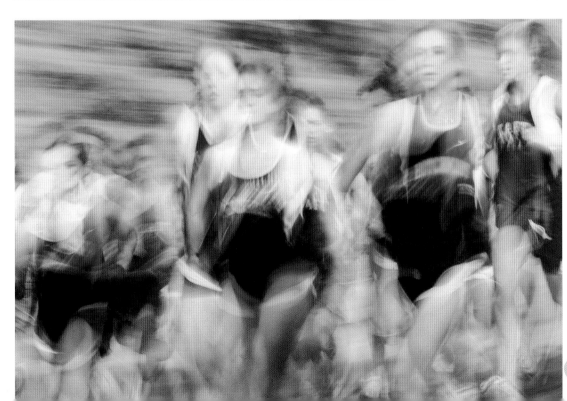

E

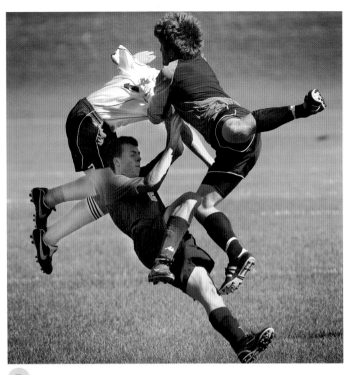

A

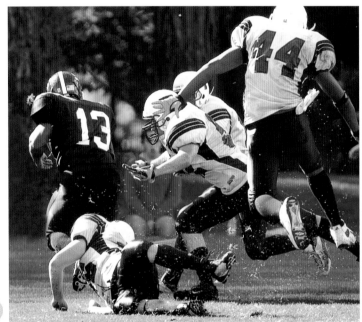

B

The Dramatic Effects of Fast Shutter Speeds

Using fast shutter speeds to capture extremely fast moving subjects will often disclose an action too quick for the eye to catch on its own. The most common examples are from the sports world, as seen in examples (a), taken at 1/1000 second, (b), taken at 1/500 second, and (c), taken at 1/750 second. Such speeds allow the photographer to capture a whole world of extraordinary expressions and postures. These speeds also help to capture fast moving small details, such as the flying bits of grass caught in midair in the football picture—image (b). In example (d), the boy running into the ice-covered lake seems to be walking on water at 1/750 second. His expression and those of the downhill riders in the next images reflect reactions ranging from fear to joy to determination; example (e) was taken at 1/250 second and example (f) was taken at 1/125 second.

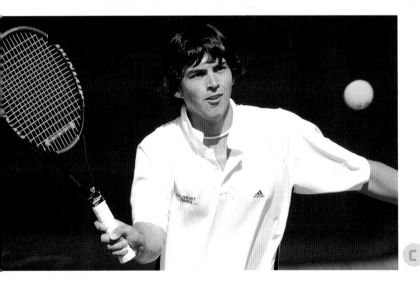

C

D

E

F

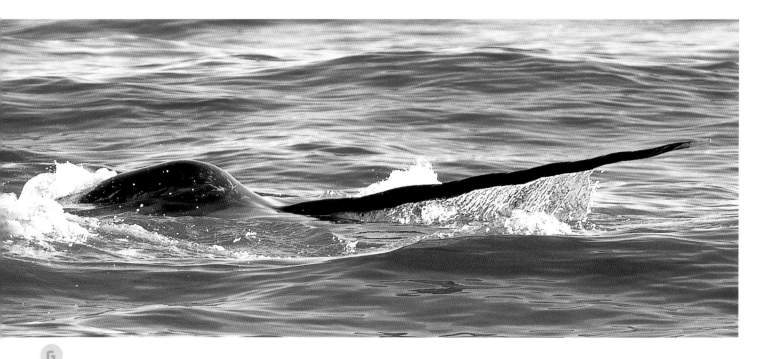

G

In wildlife photography, a fast shutter speed will often catch a moment of transition, as in example (g) where a Narwhal head and tusk are emerging with a coating of water. A shutter speed of 1/1000 second was fast enough to freeze individual water droplets dripping off the tusk of this unique mammal.

Portfolio: The Many Moods of Water

Bodies of water such as oceans, lakes, ponds, rivers, and streams, are favorite subjects of photographers. Part of the reason is that water is a medium that takes on many forms, often has a predictable movement, and can certainly be counted on to produce all sorts of different looks. You, the photographer, also have a number of options to affect the appearance of water. The main tool is shutter speed and the controlling factor is the intensity of the available light and the way it plays off the water.

Take for example a calm, sunny day on the ocean where small waves will gently lap over the sands of the beach creating a peaceful and restful mood, as in example (a). During windy weather or a storm, on the other hand, those small waves will turn into angry swirls of water, as in example (b), taken at 1/250 second to freeze the movement of the waves. A similar transition can be seen in a stream or with a waterfall, in which the lazy finger-like flow of water during a summer day (c), taken at f/16 and 1/4 second, can be transformed into volumes of crashing water following a sudden downpour (d), taken at f/11 for 15 seconds.

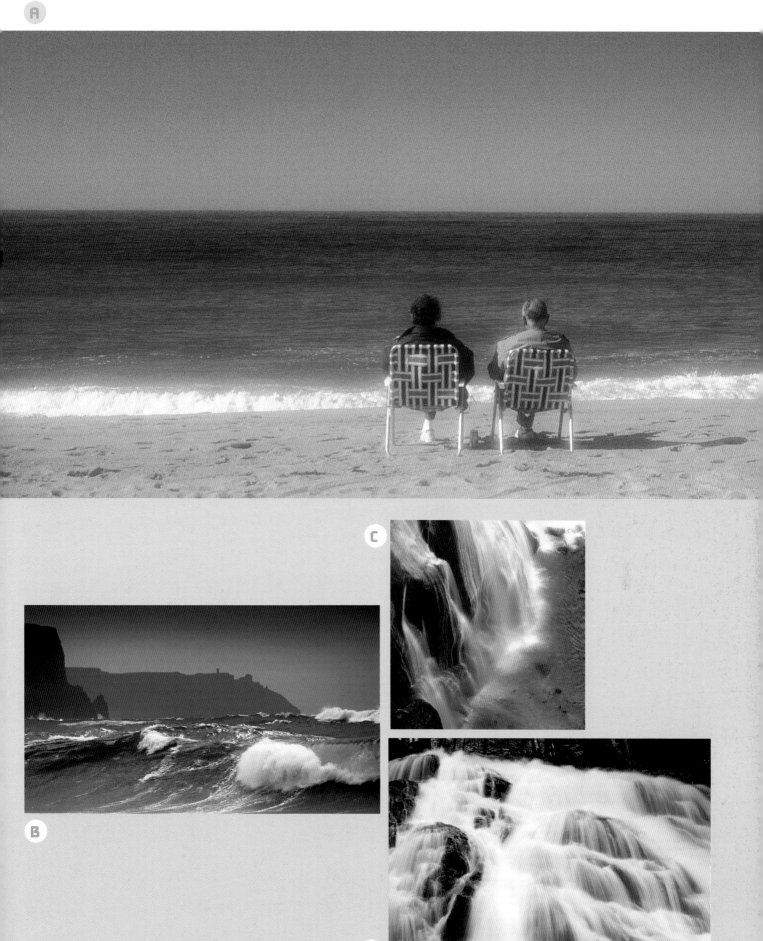

E

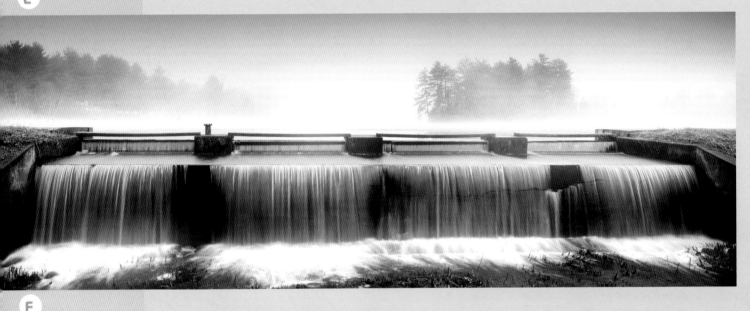

F

Perhaps the most common photographic approach to moving water is to use a slow shutter speed to produce a variety of blur patterns in combination with different lens focal lengths and perspectives. In example (e), a low perspective in combination with a wide-angle lens and 20 second exposure produced the illusion of a stream flowing toward the camera. In example (f), an eye-level perspective along with a panoramic crop and a 10 second exposure were used to isolate the flow over a dam. In example (g), an abstract effect was produced by using a 300mm lens to compress the scattered rocks along with a three-minute exposure to produce the "angle hair effect" of moving water. The Kelvin temperature of the scene was then shifted towards the cool end using RAW file processing software.

Water will also take on other physical attributes, such as the highly reflective mirror-like surface of "flat water" seen in example (h) with a half submerged dock on a windless day. Such still

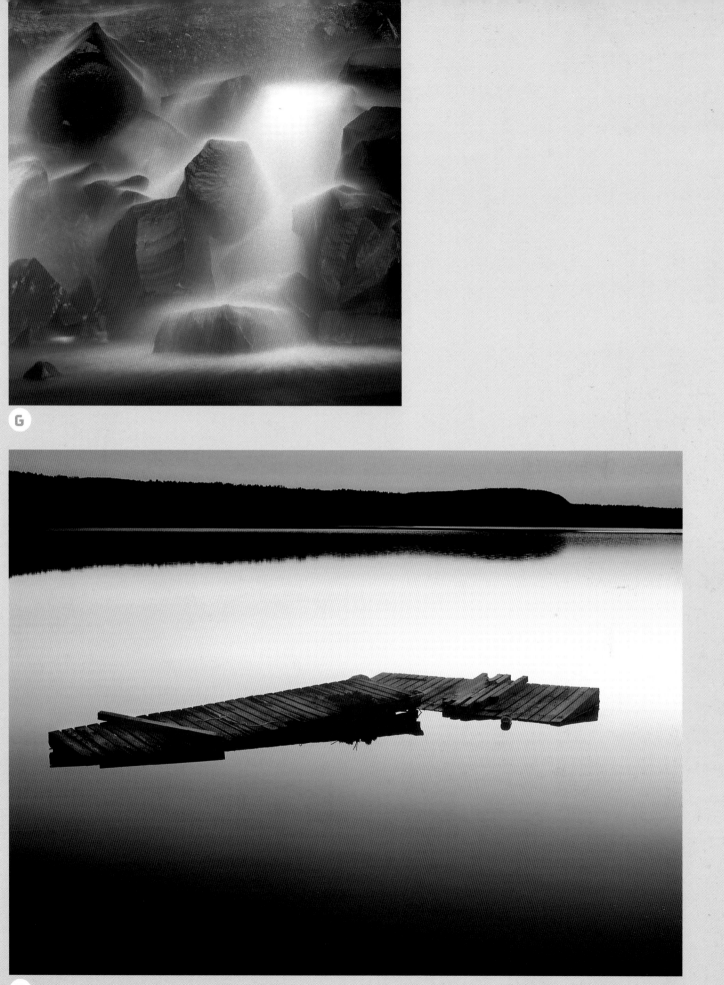

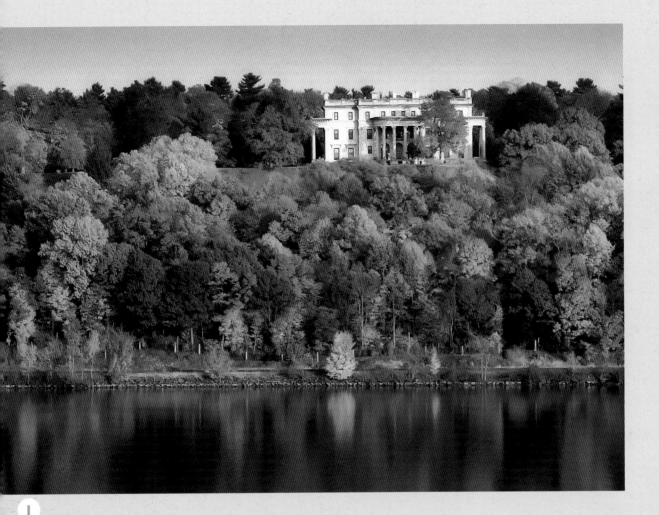

I

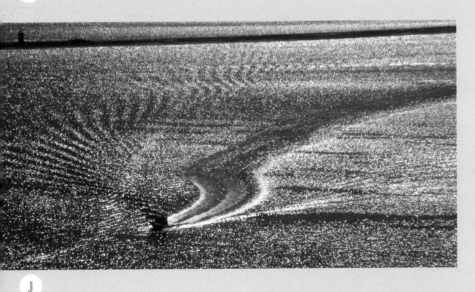

J

conditions usually convey a mood of serenity and are ideal for recording reflections, as in example (i) where river water is just slightly moving to produce a softened reflection of the house and trees. On the other hand, if something like a breeze or the wake of a boat disturbs the smooth surface of the water, it will appear rippled, such as in the high contrast almost graphic rendering of example (j). Surface ice can act as an efficient reflector of sky color as seen in the winter sunset in example (k), and small drops of water can form a pattern of sparkling textures under proper lighting conditions, as with the raindrops on the hood of a car in example (l).

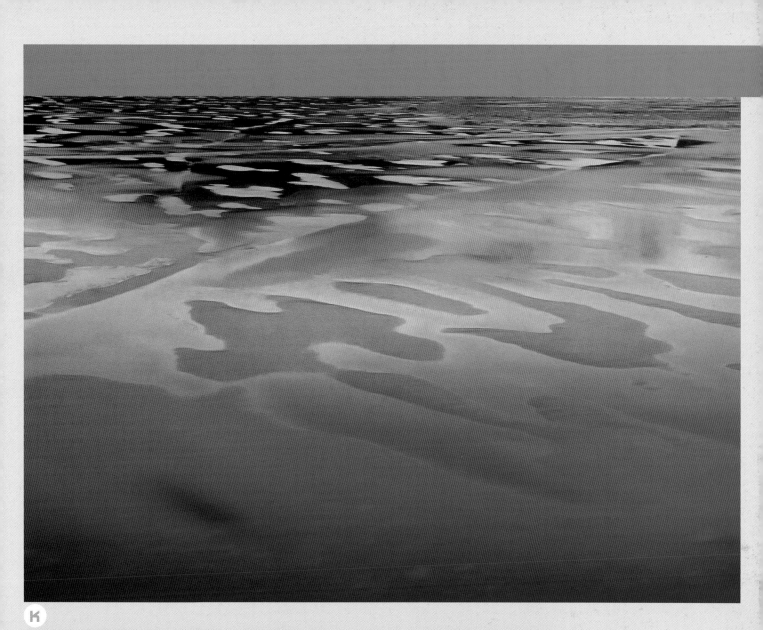

K

L

Lens Focal Length
and Camera Perspective

The selection of a specific lens focal length and where the camera is placed relative to the subject (perspective) are two great tools for producing different renderings of a given scene or subject matter. Specifically, the focal length can change the relative size of different visual elements in a scene, allowing the photographer to emphasize and deemphasize these elements to varying degrees. Camera perspective establishes the viewing point and will further influence the impact of different focal lengths. For the creative photographer, the combination of focal length and perspective are indispensable for producing dramatic renderings. Unfortunately, modern lens technology can often lull a photographer into practices that overlook these two useful tools. This is especially true of the modern zoom lens that makes it so easy to just stand still and zoom to frame the subject.

Before the development of the high-quality zoom lenses that dominate photography today, photographers relied on fixed-focal-length lenses. This gave photographers a firm visual concept of how differently a wide-angle, a telephoto, and a normal lens portray the world. All too often, the zoom lens is used today mainly to frame a subject without moving, ignoring the significant influence that specific focal lengths can have and discouraging experimentation with different perspectives. In this chapter, we will explore the power of both focal length selection and camera perspective to produce a range of different presentations.

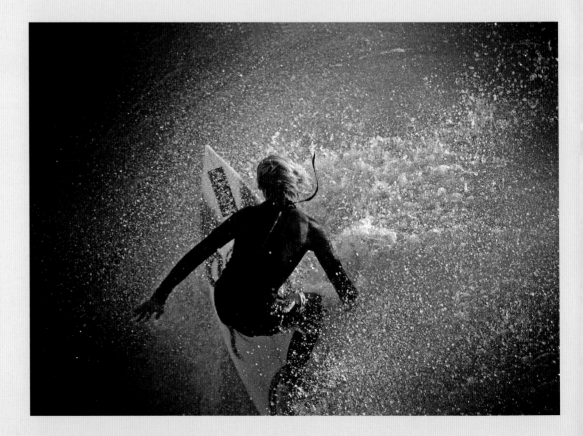

Focal Length

One of the primary functions of a lens is to set the angle-of-view for the picture relative to the size and format of the recording media. That is, how much of the total scene is going to be captured within the frame of the sensor. Most lenses used with today's digital SLR cameras are based on designs that originated with 35 mm film cameras. Thus, the focal length identification on the lens is calculated based on covering a 24 mm x 36 mm film frame size. As a result, most photographers base their concepts of wide-angle, telephoto, and normal lenses based on traditional 35mm film focal lengths. (See the chart below.)

Traditional Lens Classifications

General Terminology	Approximate Focal Length Range	Horizontal Angles of View
Normal	50mm (+/- 10mm)	35 – 45°
Moderate Wide-Angle	28mm-35mm	65 – 54°
Medium Wide-Angle	20mm-24mm	84 – 74°
Extreme Wide-Angle	14mm-18mm (rectilinear design)	100 – 90°
Full-Frame Fisheye	12mm-18mm (curvilinear design)	up to180°
Short Telephoto	85-105mm	24 – 19°
Medium Telephoto	135mm-200mm	15 – 10°
Long Telephoto	300mm-500mm	7 – 4°
Super telephoto	600mm-800mm	3.4 – 2.4°

The angle-of-view of a lens is measured either across the horizontal or vertical section of the recording frame with the lens set at infinity focus. For example, the horizontal angle-of-view for a 50mm lens across a full-frame 24mm x 36mm sensor will be approximately 40°, but it would only be 19° for a 105mm focal length lens. Since many digital cameras have sensors smaller than a frame of 35mm film, a correction factor (such as 1.5x or 1.6x, for example) has to be applied to the focal length of the lens to maintain the traditional categories for wide-angle, normal and telephoto lenses. This is because the smaller sensor will record a smaller portion of what the lens "sees," producing a smaller angle-of-view. This, in turn, changes the effective focal length of the lens. For example, that same 50mm lens used on a camera with a full-frame (35mm film strip sized) sensor will increase to the equivalent of a 75mm lens when used with a camera that has a 1.5x correction factor (50mm x 1.5 = 75mm).

In recent years, camera and lens manufacturers have been making special "digital" lenses that are designed specifically for sensors smaller than full-format. For example, a 12mm–24mm digital zoom lens made by one manufacturer is specifically for a camera having a sensor with a 1.5x correction factor. With the 1.5x correction factor applied, this zoom would be equivalent to an 18mm-36mm zoom on a camera with a full-frame sensor.

The Visual Effects of Focal Length

While angle-of-view is the primary characteristic of focal length, there is also an important additional set of effects. As the angle-of-view changes, there is an alteration in the relative size of subjects in different parts of the scene. That is, as the angle-of-view becomes wider and wider, the relative size of subjects in the foreground will be larger as compared to subjects in the middle and especially the background areas. This is sometimes referred to as "foreground dominance," in which middle and background areas shrink in size proportional to the increased size of foreground subjects. Example (a) illustrates this with the effects of a 20mm lens. Furthermore, when a wide-angle lens is used on a building, this foreground dominance seems to make the building look as though it is falling backwards (called the "keystone effect") as in example (b). Conversely, in the case of telephoto lenses, foreground, middle ground, and background areas will appear to move closer to each other causing the

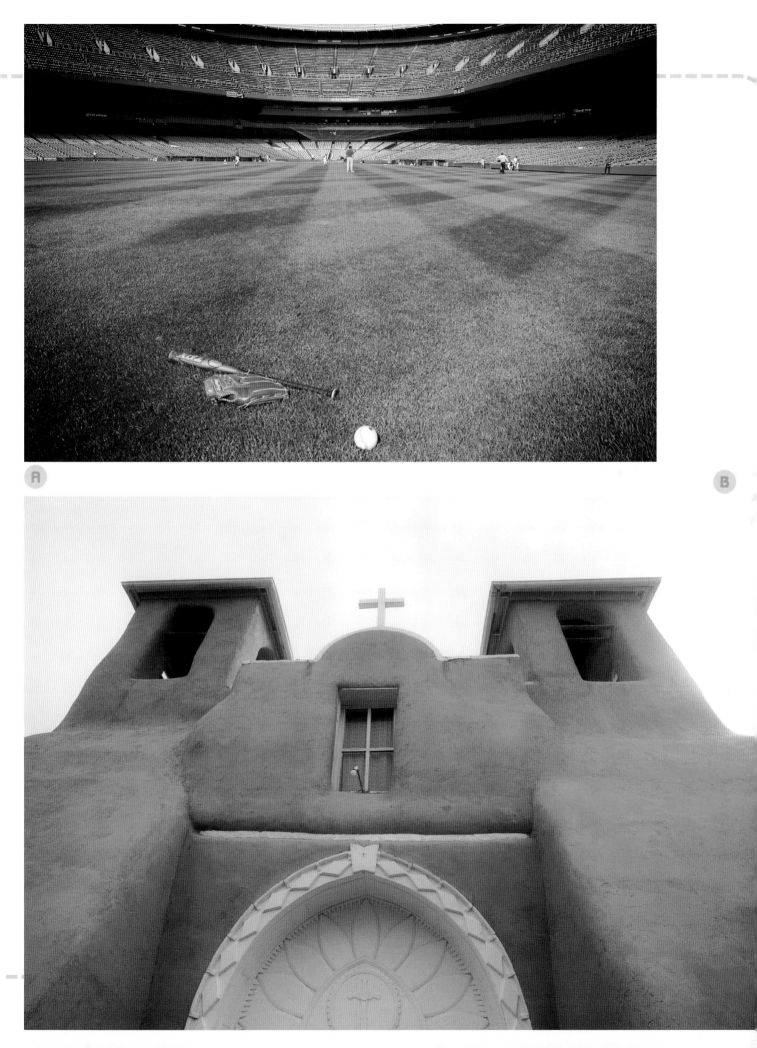

classic "telephoto compression" effect. Example (c) demonstrates this effect on the line of marchers in a parade, while example (d) shows the compression on the outstretched arms of the tennis player. Existing between these two effects is the more natural rendering of the normal focal length lens, as seen with the hay wheels in example (e).

This ability to change the apparent size relationships between parts of the scene by changing focal lengths is another very powerful tool for the creative photographer. It allows the user to emphasize and deemphasize different parts of a composition. For example, using a short focal length lens in close to a subject firmly establishes the prominence of that subject by virtue of its greater size. Yet, the wide-angle still allows for a substantial amount of middle ground and background areas to be included. Using a normal lens up close in this way would also increase the nearer subject's size, but unlike with a wide-angle lens, a normal lens wouldn't include as much of a view of the middle and background areas, and they would not appear to "shrink" as much. In other words, the wide-angle lens produces a far more dramatic effect by altering size to a significantly greater degree while still capturing a wide view.

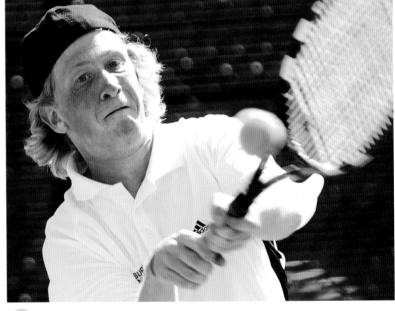

D

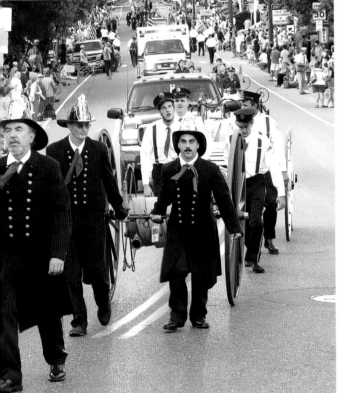

C

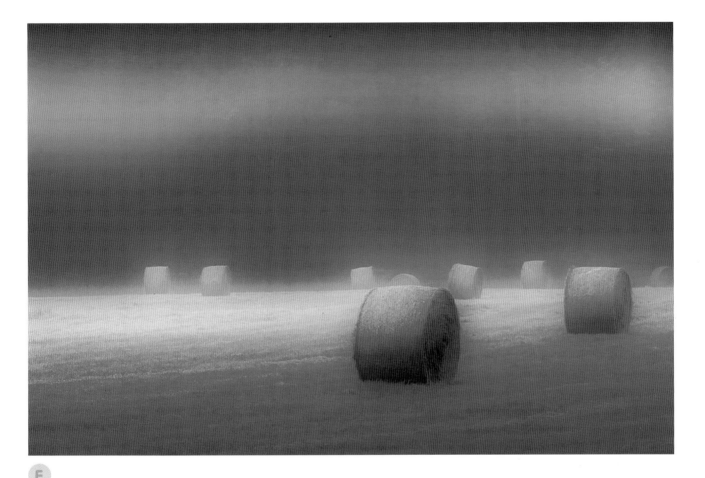

E

The opposite effect occurs when using a telephoto lens. In this case, the compression of everything has the effect of pulling distant background areas up much closer to the foreground subject. This is a very effective way to bring together distant parts of a scene. It also prevents backgrounds from being rendered small and insignificant, as might occur with a short or even a normal focal length lens. Combine these conditions with different camera perspectives and the opportunities for rendering subjects with different relative values becomes quite diverse. The portfolios at the end of the chapter illustrate these points (see pages 93 – 103).

Camera Perspective

Camera perspective refers to the position of the camera relative to the subject. A common way of separating different camera perspectives is to use the "eye level" position as a starting point. For example, in a seated head-and-shoulders portrait, this would mean setting the camera approximately level with the eyes of the subject. The object here is to present a balanced or natural perspective at a level similar to the view one has of people when sitting at a table. This was the case in example (a), where a moderate telephoto was used from a perspective of approximately the same height as the boy. Alternatively, the camera can be used in a slightly higher perspective as was done by photographer Peter R. Pierce in the imaginative portrait of his son, example (b). Typically, however, snapshots taken by adults of small children and pets

C

will have a much higher perspective, as seen in example (c). Conversely, photos taken by young children will often have a lower perspective. Yet another interesting perspective is the overhead view, when the photographer takes a position over a subject as typically happens when photographing natural close-up subjects on the ground, like flowers or small fauna as seen in example (d).

While there aren't any absolute rules about which subjects should be photographed using which perspectives, there are certainly traditional practices. For example, in the case of the formal portrait, low and high positions are generally avoided in favor of the eye level perspective. However, as illustrator Norman Rockwell commented about the use of photography for illustrators: "If you want to exalt a subject, you shoot up at him. To humiliate him, shoot down."

Perspective is often controlled by the conditions under which the photographer must function. The typical view of open field sporting events is controlled by the standing or seated perspective of the photographer on the sidelines versus the spectator's higher perspective up in the stands. Most landscapes are captured from a standing position looking straight out into the land working off an extended tripod, while architectural photographers are constantly dealing with tall subjects from a low perspective.

D

In general, the eye-level perspective and the moderate high and low variations just by themselves do not convey a strong dramatic impression. The chances of producing a more unusual presentation are increased when the camera is positioned to capture the scene from a more extreme perspective. For example, try shooting at or near ground level, as in the mushroom image in example (e), or up high in a window, on a hilltop, or in an airplane, as illustrated in the portfolio on aerial photography on pages 102 – 103.

Summary

Aperture, shutter speed, focal length, and perspective are critical tools to the photographer who is looking to control the relative importance of subject matter in front of his or her lens. Aperture controls of depth of field, shutter speed controls the portrayal of motion in an image, lens focal length controls the degree of image compression or foreground dominance, and camera perspective controls point of view. These four tools of photography can combine to significantly alter the importance of various visual elements in a scene to fit your individual photographic goals. What remains to consider now are the ways in which color and texture can be altered using white balance, ISO settings, and camera filters. In the next chapter, we'll explore the possibilities.

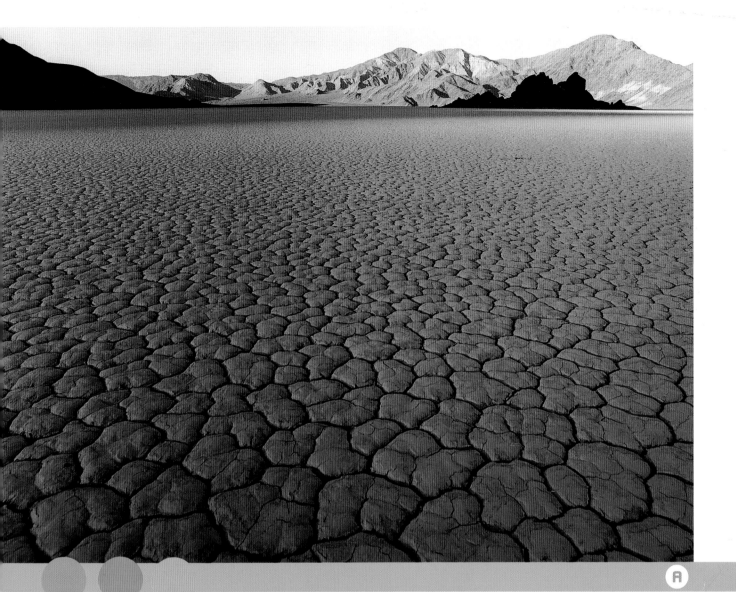

Portfolio: Moderate Wide-Angle Lenses + Low Perspective

The primary function of the wide-angle lens is to capture more of the scene than would be record-ed with a normal or telephoto lens. The cracked mud flats image, example (a), is a typical use of a moderate wide-angle 28mm lens shooting from a low level perspective. The cracked mud sections appear significantly larger in the foreground, becoming significantly smaller in the middle ground, and eventually becoming very tiny in the background. Yet, there is no noticeable distorted stretch-ing of shapes at the corners of the picture. Instead, the gradual change in relative size of the mud patterns helps to establish a sense of depth. Thus, the advantage of a moderate wide-angle lens is the ease with which it can be brought in close to enlarge and dramatize the foreground without resulting in major image distortions.

B

This was also the case with the small puddle in the foreground of example (b), measuring perhaps the width of three tire tracks, versus the size of the large dilapidated building in the background. The same thing is happening in example (c) but from a near eye-level perspective using the wing of the plane to frame the departing helicopter in the background. In the rock structure in example (d), a moderate 35mm wide angle was positioned very close to the rock in the foreground, producing what amounts to a close-up representation while still including the rock formations at a large enough size in the background. A moderate wide-angle lens was also the best choice to come in close to the scientist in example (e) to enlarge and therefore establish his importance in the scene while still bringing in the laboratory setting without distortions or appearing excessively reduced in size.

C

D

E

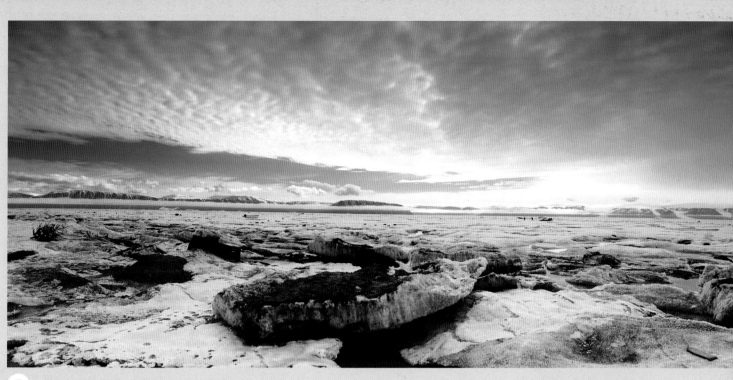

(A)

(B)

Portfolio: Extreme Wide-Angle Lenses + Low Perspective

Shorter focal length lenses used at or near a ground level perspective will produce even more extreme changes. That is, they will capture the widest background field with the greatest exaggeration of foreground subject size, all while greatly reducing the relative size of subjects in middle and background areas. All three of these effects can be seen in example (a) where the camera was placed about 8 feet away from the chunks of sea ice. This exaggeration of size by a 20mm lens set at f/16 can also be seen in the sky area nearest the top of the frame. The fan-like leading lines receding into the background help to support the feeling of depth. Note the panoramic crop to isolate the main subject matter along the horizon that adds further to the wide-angle effect. In example (b), the vertical format helps exaggerate the effect of a 24mm lens and a very low perspective on the side-lit mud flats in the foreground. The line of tall trees in the background have been reduced in size so as not to compete with the small mud textures, while the curve of the mud edge has been exaggerated by the stretching effect of the wide-angle lens

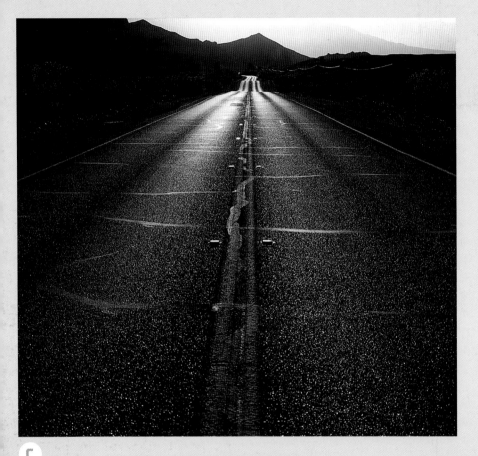

The combination of a very low perspective and extreme wide-angle lenses is also very effective at dramatically enhancing leading lines in the lower half of a composition. For example, the highway lines in the center of the roadway at sunset in example (c) form a pronounced reversed "V" when photographed with a 20mm lens and the camera positioned about two feet from the ground at f/22 to keep these leading lines sharp. The same effect can be seen in example (d), taken at a New England July 4th parade with the same lens at f/16-22 and the camera placed on a beanbag set on the ground. In addition, the parade picture was given a weak solarization filter treatment using image-processing software.

C

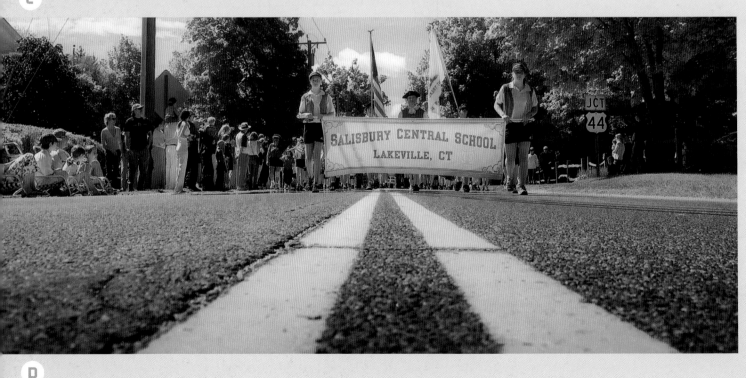

D

E

F

The same dynamics of foreground dominance and low perspective are at work in the photograph of the granite tower in example (e). Here, the camera was positioned low to the ground and rested against the base of the tower on a beanbag using an 18mm focal length. This caused the base to be greatly exaggerated in size, giving a very dynamic quality to the presentation. A digital camera converted to record infrared light was used to take this picture. (See pages 168 – 189 for more information on infrared photography.)

In example (f), the foreground is again exaggerated, this time with a 24mm lens set at a low perspective, greatly increasing the size of the foreground columns and forming an interesting framework for the rest of the picture. I used a 14mm focal length in example (g) to record the reflection of the art deco main building across the plaque dedicating New York's

Rockefeller Center. The wide angle-of-view was also large enough to capture a portion of the golden statue of Prometheus and the ring of national flags in the plaza just beyond the plaque.

G

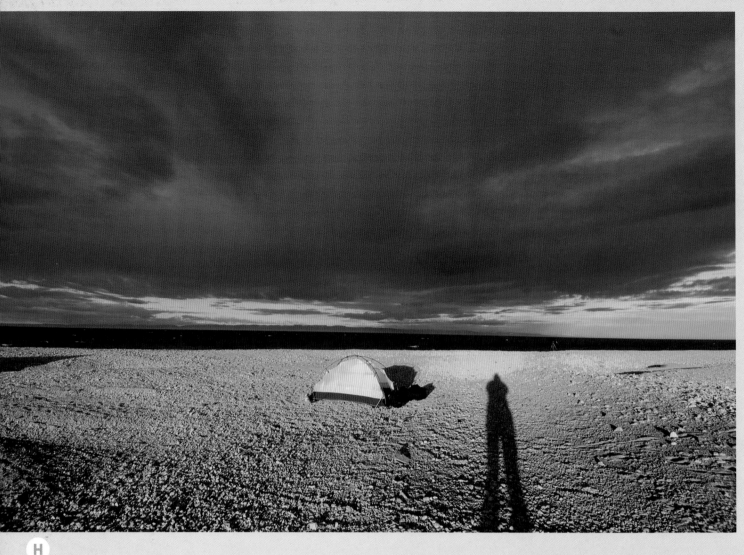

H

I

Shorter extreme wide-angle lenses are so powerful in their effect on the relative size of close and far objects that one needs only to tip the camera up or down in a standing position to produce extreme changes. This is demonstrated in example (h) where a 15mm focal length literally stretches my shadow up into the center of the picture while producing a fan-like shape to the overhead clouds. The same dramatic effect is seen in a close-up perspective in example (i) where a 15mm lens was placed just inches from the outstretched hand of the man reaching for a piece of paper.

A

B

C

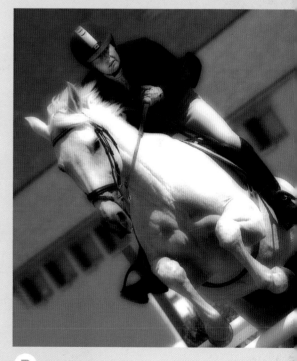

D

Portfolio:
Dramatic Telephoto Impressions

Most photographers begin using telephoto lenses in order to bring a distant subject closer, as in the case of the sea bird in example (a), taken with a 500mm lens at f/16, and the hockey players in example (b) taken with a 70-200mm zoom at 200mm and f/2.8. Telephotos are also used to isolate action, such as the baseball pitcher's expression in example (c), taken with a 300mm lens at f/2.8, and the jumping horse and rider in example (d), taken with a 70-200mm zoom at 150mm from a low perspective. The soft effect in this image was produced by using a soft filter in image-processing software.

Telephotos characteristically compress the visual differences between subjects, allowing the creative photographer to control the visual separation between these parts relative to each other. In example (e), the distant hills some six miles away have been drawn up close to the houses to form a strong background with the use of a 80-400mm zoom at 400mm and f/22, supplying the necessary depth of field from an eye-level perspective. In example (f), a lower perspective in combination with a 350mm focal length "pulled in" a distant scoreboard to a position above and framing the lacrosse players despite the fact it was located across the field. The f/8 aperture supplied just enough depth of field so that the board was only slightly out of focus but still legible.

Compression is again at work in example (g) between the girl with the hose and the fleeing children, taken with a 300mm lens at 1/350 second to freeze the spray. This compression was a necessary visual element to make children trying to escape the spray seem very close to the girl with the hose. In the picture of the two people climbing the stairs in example (h), compression is used to render the stairs more like a background, aided by the eye-level perspective out of a window from a nearby building.

E

G

F

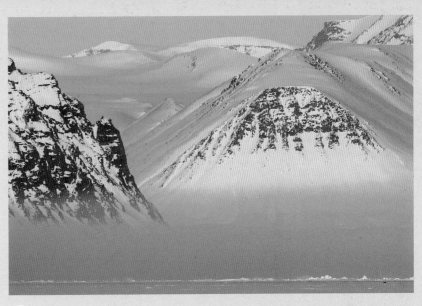

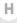

Long and super long telephoto lenses are a favorite of some landscape photographers because of their ability to compress visual elements that may be too far apart to provide a sense of integration. This is the case in example (i) where the sprawling snow covered mountains have been drawn together through compression using a 600mm focal length at f/22 for sufficient depth of field, as well as with the sand dunes and the distant mountains in example (j), taken with a 500mm focal length at f/16. A higher perspective and a 400mm lens at f/22 was used in the autumn landscape photo in example (k) to bring together the entire scene that represents approximately 8 miles from camera to the far background.

Portfolio: Aerial Views

The view that an aerial perspective gives to a scene is quite different from earth bound photography. In general, as the angle to the ground comes closer to a 90-degree perpendicular arrangement shooting straight down at the ground, subject matter will flatten and the sense of depth will be minimal. This can be seen in example (a) where a 35mm focal length was used to capture an industrial section of an urban area. To obtain more depth in the composition, the camera perspective needs to be at less of an angle to the ground. This usually requires the use of a normal focal length or a short or medium telephoto, as in example (b), which captures a portion of suburban sprawl in the American southwest. An even sharper angle is shown in example (c) of a coastal town using a 120mm focal length at f/22. Sunlight reflecting off the water in example (d) provides a more dramatic appearance, taken with a 28mm focal length.

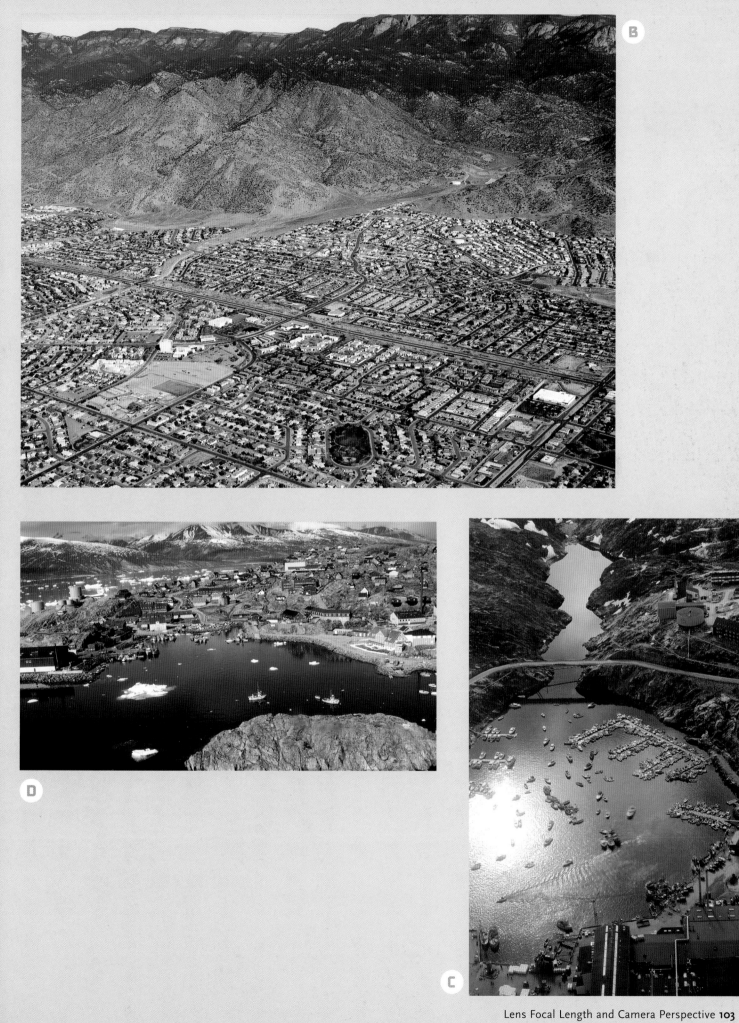

White Balance,
ISO, and Camera Filters

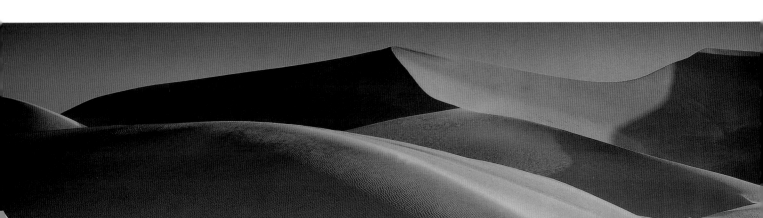

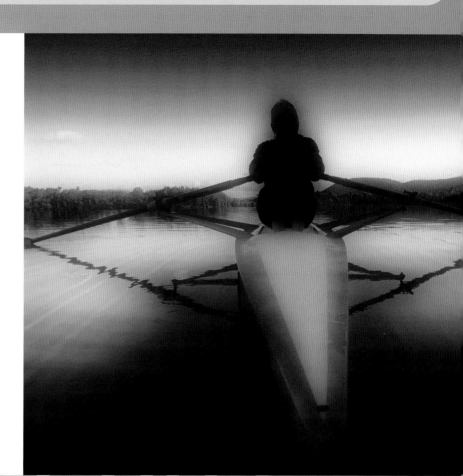
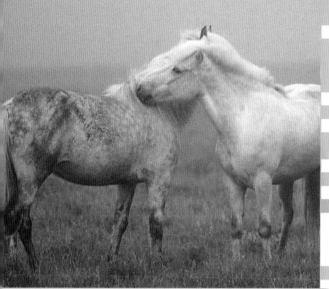

electing a light-appropriate white balance setting is intended to produce results that are neutral in tone, without colorcasts, while the lowest ISO setting generally delivers an image with the lowest noise level. However, as with the selection of aperture and shutter speed settings, these basic digital camera tools can also be used to produce something beyond their standard purposes. For example, instead of using white balance to achieve a color neutral recording, the photographer can help establish a mood by using the "wrong" white balance mode for a particular light source, resulting in a warm or cool colorcast. Camera filters also have the capability to be used in a routine corrective role as well as to introduce a number of other effects. In the case of ISO, a very high ISO number such as 1600 or 3200 will increase the noise level to the point of reinforcing a gritty rendering of the scene that can be very appealing in some cases, particularly with black and white images.

This chapter focuses on the alternative applications of these three camera tools (white balance, ISO, and camera filters). As in the two previous chapters, we will first review the primary purpose of each of these tools. Then, we will turn our attention to the potential opportunities each offers for personal expression by the creative photographer.

White Balance

s summarized in The Color Composition of Light chart back on page 33, light will vary in terms of its color content according to the physical makeup of the source. Modern digital cameras have several white balance modes intended to adjust to these differences, much like the light balancing and color conversion camera filters that were traditionally used with color films. The white balance choices typically consist of a series of modes for common Kelvin temperatures in which the proportions or warm and cool wavelengths vary. These modes may have names like (or similar to) Sunlight, Shade, and Cloudy for natural light, and Tungsten, Flash, and Fluorescent for artificial light sources. Most digital cameras also have an Auto white balance mode, designed to make a generalized adjustment to different color temperatures, and a Custom white balance mode, used to lock in an

exact Kelvin color adjustment. Some cameras will also allow the user to dial in a specific Kelvin temperature value obtained from a color meter reading, or when the exact Kelvin temperature of a source is known (such as when working under 3200 degrees Kelvin rated halogen lighting, commonly used for copy stand work). Finally, there is also the opportunity to adjust color temperature later in the computer using various software programs.

In addition to their corrective role, white balance settings can also be used to produce a warm or cool colorcast to support or establish a certain mood or ambience. This may be as subtle as the slight warming or cooling of a scene or as drastic as significantly altering the color with colorcasts for a more extreme effect. The key is to set the camera to a mode that will produce a particular colorcast under a specific type of lighting. For example, if you're shooting under bright sunlight or using flash (both types of light have a Kelvin temperature of approximately 5500-5600 degrees) and you use the Tungsten (or similarly named) white balance setting, the image will be recorded with a blue colorcast. On the other hand, setting the camera's white balance to record sunlight when photographing under tungsten light will result in a warm, reddish colorcast.

Colorcasts ranging from weak to very strong can also be easily introduced after capture in the computer using a number of different techniques. If the capture is done in the RAW file format, a warm or cool colorcast can be easily produced by altering the Kelvin Temperature when the file is processed. In addition, any general image-processing program will have the ability to warm or cool the image as well as introduce other color shifts. Finally, just about any of the many plug-in programs that deal with adjusting color can also make these changes.

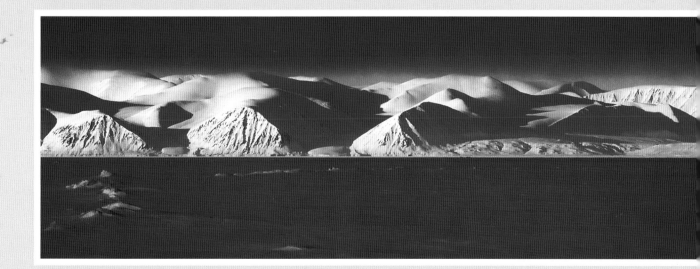

Colorcasts and Noise Levels

All of the images in example (a) were exposed using a digital SLR and an electronic flash in a studio soft box. In the first image of the top row, the camera's white balance was set to Flash, producing the color neutral result labeled "Control." Since the light of the studio strobe is close to color neutral daylight, all of the results in the image example at right approximate results that would be produced in daylight. The remaining pictures in the top row were then taken using the same light source but with different camera white balance settings as indicated: Cloudy, Tungsten, and Fluorescent.

The color shifts seen in each of three white balance exposures represent the way the camera's white balance settings would compensate for the colorcasts in their respective sources. That is, the high Kelvin temperature of a cloudy day has a higher proportion of blue, which requires the addition of warmer tones to provide a neutral rendering of the scene. So, when used with a neutral source like a studio strobe, the Cloudy white balance setting produces the slightly warm result (as seen in the frame labeled "Cloudy"). In the case of the low Kelvin temperature of warm tungsten light, the camera's matching white balance setting compensates with a shift to blue to produce a neutral rendering. When using the Tungsten white balance setting under neutral lighting conditions, as seen in the frame labeled "Tungsten," a blue colorcast will result. For the last frame, labeled "Fluorescent," the image shows that this white balance setting produces a shift toward magenta, the complementary color of green, to offset the green spike of fluorescent light.

The second row of images in example (a) shows the effects produced by using various warming and cooling software filters on images shot under the same studio soft box lighting with the camera set to the Flash white balance setting. The filter notations for each frame represent the software effects designed to mimic their equivalent color conversion and light balancing camera filters used with film (the strong 80 and 85 conversion filters and the weaker 81 and 82 light balancing camera filters). The strength of each of the software filters represented here can be adjusted via a slider in the software program, from 1% all the way up to a full 100% strength. The examples shown represent some of the different percentage settings available in the program.

| Control | White Balance "Cloudy" | White Balance "Tungsten" | White Blance "Fluorescent" |

| Photoshop "81" (25%) | Photoshop "85" (50%) | Photoshop "82" (25%) | Photoshop "80" (50%) |

Adjusting Kelvin Temperature in RAW Files

One of the most powerful image management choices in digital photography is to shoot RAW files. Unlike the omnipresent JPEG format, RAW files do not process or compress the data in any major way. It is roughly analogous to a roll of film that has been exposed but not processed, a kind of digital negative that can easily be altered and manipulated later in the processing stage. Thus, the photographer can make significant changes in the key qualities of the recorded light captured in the file before saving it to one of the two most common photographic file formats: JPEG or TIFF. Exposure, contrast, brightness, shadows, and Kelvin temperature can all be adjusted using either the camera manufacturer's RAW processing software or a third party image-processing program that is able to read your camera's RAW file format.

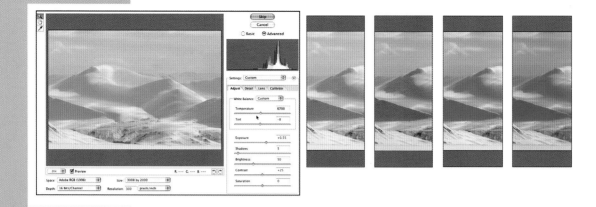

An original capture of the snow scene in the example above was made in diffused sunlight, as displayed in the Adobe Photoshop RAW File Reader software dialogue box. I then adjusted the Kelvin scale to give a series of four different results (two warmer and two cooler). This was done by simply moving the Kelvin Temperature slider (upper right hand corner of the dialogue box) a few hundred degrees for each change. Making such color changes is a non-destructive procedure in terms of the file color data when carried out on an original RAW file in a RAW file reader.

ISO Sensitivity and Noise Levels

The ISO setting on a digital camera raises or lowers the relative light sensitivity of the sensor. This numerical relationship is basically the same as the ISO ratings of film in that the higher the sensitivity to light the less light required for a correct exposure. As the digital ISO rating increases, so does the amount of noticeable noise and other unwanted artifacts in the image. (This parallels the general increase in the appearance and coarseness of grain as the ISO rating of film increases.) The higher level of digital noise is usually taken as undesirable by photographers and noise reduction software is often used to clean up the image. On the other hand, the introduction of noise from a high ISO setting can be used creatively to give a grain-like appearance to the scene, suggestive of the look produced by high-speed films. The end result can be something that supports a particular ambience or emphasizes textures already present in the scene. Alternatively, this gritty look can be augmented by using image-processing software to add a film grain pattern.

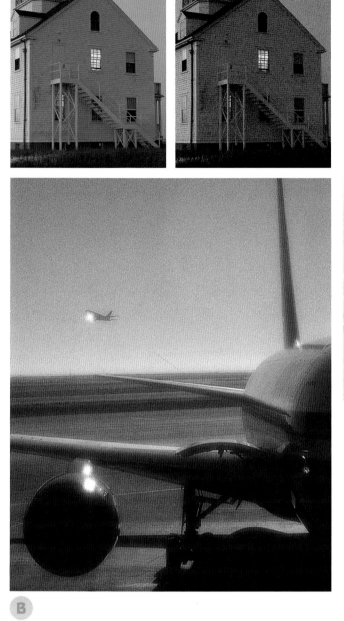

Besides the increase in digital noise with higher ISO ratings, underexposing the image will also noticeably raise the noise level. In example (a), the building was first exposed correctly at dusk (left) and then underexposed by one stop (right), producing significantly more noise. As pointed out in the previous section, higher noise levels can add a gritty feeling to an image while also giving the impression of a high speed film, as seen in example (b) taken through the window of an airport waiting room at ISO 1600 after sunset with the white balance set for fluorescent lighting, as well as in example (c), also taken at an airport at ISO 3200 on a heavy overcast day and then processed further using an old photo style software filter.

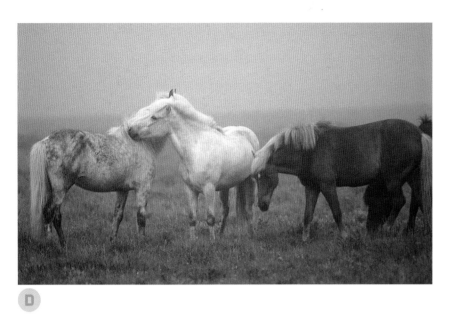

D

E

There is also the option of adding the look of film grain using image processing programs. In examples (d) and (e), I added grain to add texture to the original images of Icelandic horses on a misty overcast morning. Some software programs even allow you to reproduce the look of particular film types, including some emulsions that are no longer available. This was done in example (f) where, from left to right, you can see the original image with no added software treatment, then a software effect designed to emulate Kodak Professional Portra 400 film, next is a generic ISO 1600 software effect, and finally a Kodak Professional Tri-X 400 black-and-white film effect.

F

Using Filters

Most camera filters are designed to deal with adjusting the color content of a light source when working with film. In other words, they are designed to correct for an imbalance between the chromatic content of the light and the way that film records color. The major groups that perform this task include light balancing, color correction, and color compensation filters. All of these can also be used on a digital SLR to perform the same tasks. Today, however, many digital photographers carry out such corrective procedures using a digital camera's white balance settings, or simply make the corrections later in the computer.

In addition to filters dedicated to color correction, there are also a number of other filters that are very useful, indeed indispensable, in many cases to the digital photographer. In particular, the use of polarizing filters, neutral density filters, graduated color and neutral density filters, and a whole range of soft focus and diffusion designs can come in very handy when trying to render a subject or scene to your own creative vision. Each of these camera filter groups perform a task that, in most cases, cannot truly be duplicated in the computer.

Polarizing Filters

Polarizing filters, commonly referred to as polarizers, are often used to reduce glare reflections from surfaces such as windows and water, as well as to darken and enhance the color of clear blue sky areas. With the modern technology used for focusing and metering in today's digital cameras, be sure to use a circular polarizer as opposed to a linear design; linear polarizers can interfere with the automatic focus and metering mechanisms. To use a polarizer, you rotate the front filter element until the desired effect is seen either by looking directly through the filter or through the viewfinder with the filter mounted on your lens.

Surface reflections can be made up of several different forms of light. For example, a simple direct reflection from a smooth surface is often referred to as a specular reflection because of its overexposed appearance in an otherwise properly exposed scene. As a result, subject color and details in the area where the specular reflection occurs will likely be washed out entirely. This is not surprising since direct reflections are actually mirror images of the light source.

The type of direct reflection referred to as glare is differentiated from a specular direct reflection by the fact that the light coming off of the surface has been polarized. As such, it is susceptible to manipulation by a polarizing filter. When placed at an angle of 40 - 50° to the surface, the crystal alignment within the filter is capable of blocking the polarized light. This allows color coming off of the surface to be recorded. The classic example is the removal of bright reflections from wet tree leaves after a rain in order to produce a dramatic full saturation of colors.

A polarizer will not remove or mitigate a specular direct reflection, only glare. Specifically, direct specular reflections from bare metal such as chrome bumpers, silverware, and unpainted metal tools do not contain polarized light. On the other hand, reflections from glass and plastic surfaces, smooth painted surfaces, shiny paper, and glossy photos are usually made up of large quantities of polarized light.

This reduction in unwanted glare reflections does not always work completely since sometimes both simple specular and glare reflections are present simultaneously. The only way to know is to try using a polarizer within the proper angles and see if it has an effect. Keep in mind that a polarizer will reduce the amount of total light reaching the camera sensor by as much as two stops, depending on what degree of polarized light you have rotated the filter to block out. This also means these filters can be used as light reducing neutral density filters provided the glare reduction and/or blue sky effects are acceptable for a particular scene.

The most popular use of a polarizer in photography is to darken the blue color of clear sky areas without affecting other colors in a scene. When the sun's light hits the atmosphere it scatters and polarizes much of the light. The action of a polarizing filter blocks unwanted reflected light to allow a richer color to be recorded. If clouds are present, the dramatic contrast between the white clouds and deep blue areas can be even more pronounced. The increase in the density of the blue can vary from just noticeable to an extreme effect in which the sky turns a dramatic blue-black.

Example (a) illustrates how the degree of change is controlled by the progressive rotation of the filter. Thus, the photographer can choose to deepen the blue just enough for a well defined sky, as seen with the church in example (b), or for a more extreme effect to support an abstract architectural interpretation, as in example (c). The ability to make such changes will vary great-ly because the "blue sky" effect is not even across the whole sky. It is the location of the sun that will determine where the maximum blue-sky effect occurs. A simple method for determin-ing this is to point to the sun with your forefinger while raising your thumb to form a right angle with the forefinger. Then rotate your hand 180° while keeping the forefinger pointed at the sun. The arc in the sky drawn by the thumb represents the area of maximum effect. As the distance from this point to the sun increases, the effect is gradually lost, and the same is true when moving to the horizon. In example (d), taken right at sunrise over an ancient American Indian ruin, the arc drawn by the thumb held perpendicular to the earth was directly overhead indicating just a limited strip of blue-sky effect. Once the sun comes up, the sky area effected by a polarizer filter becomes more useful in terms of typical subject matter, as demonstrated in examples (b) and (c). When the sun's location does not permit an adequate amount of blue-sky effect, a blue graduated camera filter or a software filter equivalent applied in the computer can be used; in example (e), I used a medium blue graduated camera filter.

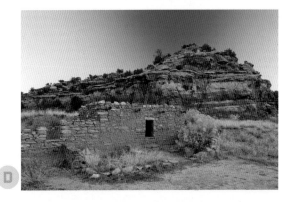

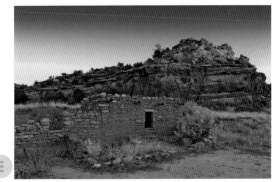

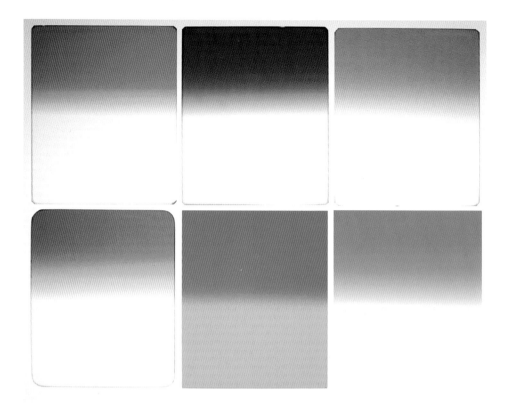

Graduated Camera Filters

Graduated filters have approximately half of the filter surface covered with a graduated spray of either neutral density or colored filter material. The most popular use of a color graduated filter is to introduce color into drab sky areas. Besides the single color style, there are also two color versions, each one covering opposite half portions of the filter. The most popular and easiest to use form is the rectangular style designed to slide up and down in a filter holder attached to the front of the lens.

The graduated neutral density (ND) filter at the far right end of the bottom row is commonly used to lower the brightness of sky areas to within the exposure latitude of the camera sensor. This helps to prevent overexposing these areas and washing out any cloud formations. "ND grads" can also be used to darken clear or overcast sky areas; on an overcast day, this added darkening can really boost the "moody" feel of the scene. Skies can typically account for anywhere from 20 – 40% of the total area in an average landscape. If this area is weak in color, or it lacks cloud detail, it can detract from the whole presentation.

There are many ways to replicate the effects of both graduated ND and color filters in the computer. The most common approaches involve using graduated masking tools in a general imaging processing program, or specific graduated filter choices within a plug-in software program.

Graduated Filter Software Effects

The easiest way to add a graduated filter effect in the computer is to use a specific graduated filter selection from a plug-in program such as Nik Color Efex software, as seen in example (a). This program's dialogue box contains several controls that allow you to modify the strength, size, and location of the filter, as well as apply either a color or an ND layer. You can select any color within the photo as well as a complete range of colors available within the program, as seen in examples (b), (c), and (d – on the following page).

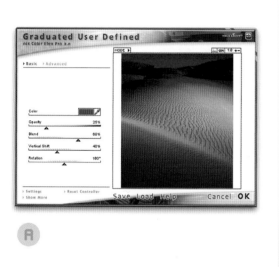

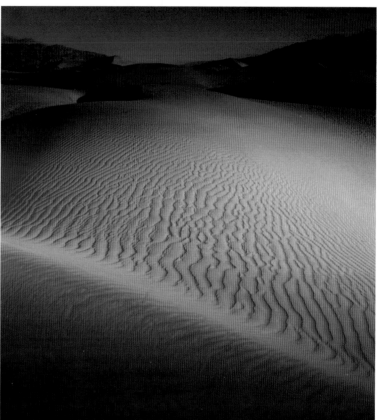

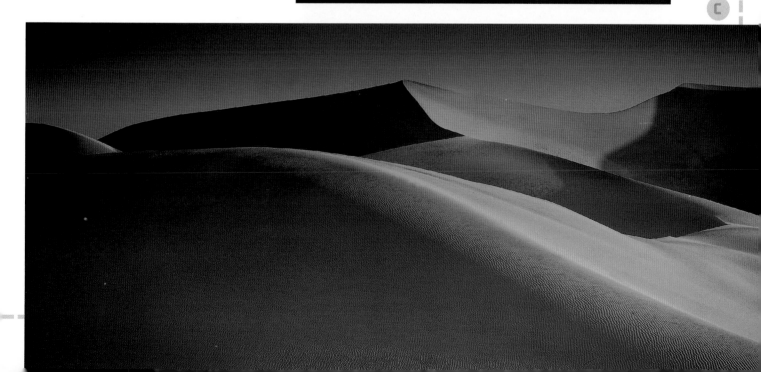

It is also possible to apply more than one graduated effect, as was done in example (e) where a warm color was applied to the top of the image and a cool layer to the bottom. Combining camera and computer graduated effects is yet another option. In example (f), a graduated light blue camera filter was used in the top section of this film capture. Then later in the com-

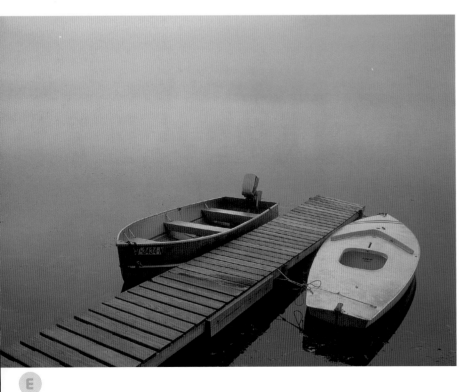

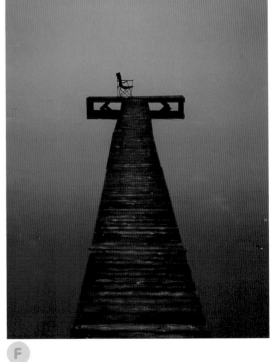

E

F

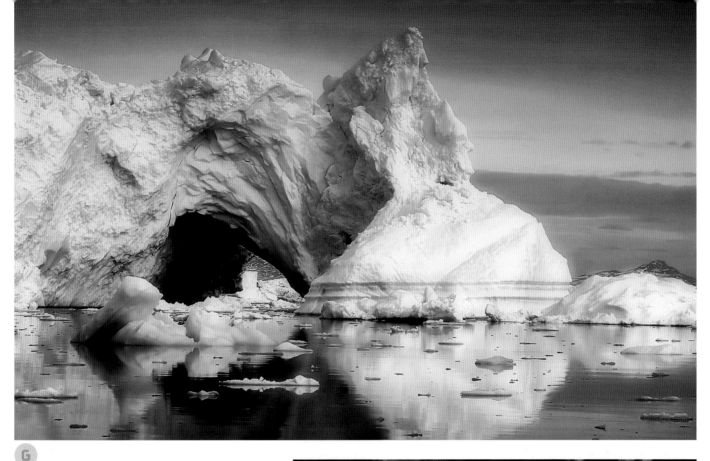

G

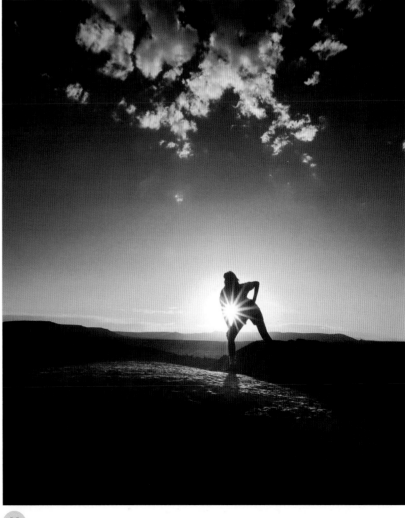

puter, a warm graduated filter effect was added across the very top section. Using small amounts of graduated color effects is preferred by many photographers, as seen in the sky areas of examples (g) and (h). The star pattern of the sun in example (h) was produced by using a very small aperture.

H

Graduated and ND filter effects can be applied by using the graduated tool available in most general imaging processing programs. One very effective plug-in that simplifies this procedure is the "Burn Tone" option in Pixel's Genius's PhotoKit software, shown in examples (i), (j), and (k). This is basically a controlled burning-in action for between 1/4 – 2/3 of the picture area that produces a result similar to applying a graduated ND filter effect from Nik Color Efex software, shown in example (l).

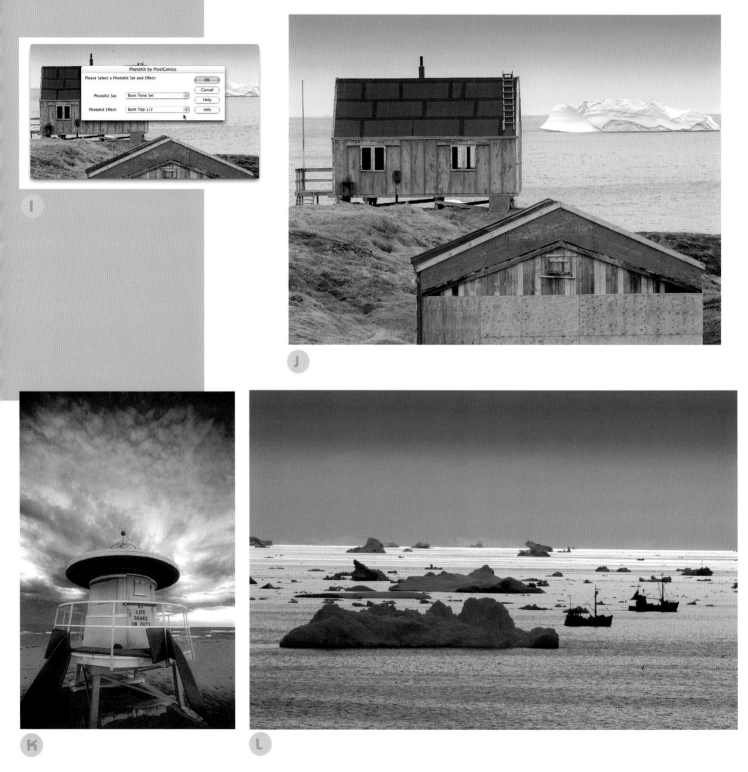

Neutral Density Filters

Full neutral density (ND) filters have a layer of light blocking materials that evenly covers the whole filter surface. Their sole purpose is to block a specific amount of light from entering the camera without causing any color changes. These filters are available in a wide range of densities so that you can reduce the amount of light in specific increments as measured in f/stops. As with all filters that block some light, a filter factor rating indicates how much light is being absorbed by the filter as summarized in the chart below.

ND filters are extremely useful accessories when there is a need to expose at very slow shutter speeds, such as when rendering flowing water in a stream or waterfall, or crashing waves with a smooth "angle hair" blur or a mist-like appearance. Very often, an exposure of at least several seconds if not several minutes is required for some of these effects. (See The Many Moods of Water section on pages 76 – 81.) Another popular use is to obtain a slow shutter speed blur in bright light, as in a pan blur of runners in a foot race. An ND filter makes it easy to reduce the light so that such slow shutter speeds can be used even in full daylight.

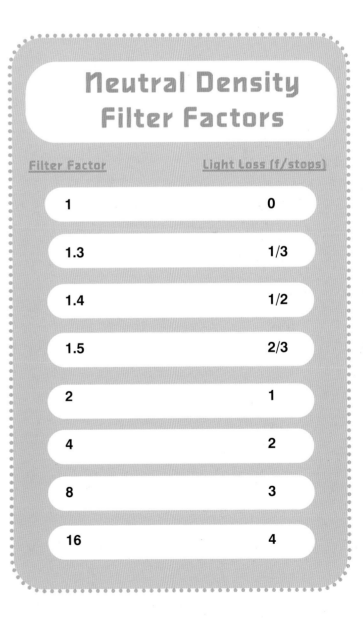

Neutral Density Filter Factors

Filter Factor	Light Loss (f/stops)
1	0
1.3	1/3
1.4	1/2
1.5	2/3
2	1
4	2
8	3
16	4

Soft Focus/Diffusion Filters

Soft focus, diffusion, fog, mist and similar camera filters are used for everything from evoking a mood in a portrait to adding various atmospheric effects to a landscape. The choices from filter manufacturers are quite extensive, and the effects range from subtle to extreme. In addition, digital photographers will often use software programs to introduce soft focus, diffusion, and related effects, of which there are many choices available.

The most important difference between on-camera and in-computer filter approaches is that a camera filter is affecting the light as it enters the camera. Since camera filters are dealing with the light that is reflecting off of different surfaces and coming at the camera from many different directions, the opportunities for obtaining unique results are quite significant. By contrast, software programs deal with light that has already been captured and usually have a more generalized effect.

There are several soft focus and diffusion camera filters that have been designed for very specific applications. For example, many weak soft focus filters are made to reduce unwanted skin flaws in portraits without significantly affecting sharpness, while stronger soft focus filters will add an ethereal mood to a setting. Fog, mist, and similar filters are used to enhance or to add an overall strong atmospheric ambience. Many of these filters are available in "warm" versions in which a weak warming filter material is combined with the primary filter effect.

While it is generally true that filters made for film cameras can be used with digital cameras, one group has been known to cause problems with digital sensors. These are the so-called "net" filters that use a dark fabric netting sandwiched between two pieces of glass. With film, the result is a subtle reduction in small flaws, often accompanied by a slight and pleasing glow. This has been a tried and true technique among film directors and portrait photographers for generations. When used with the mosaic pattern of digital camera sensors, however, a resulting imposed pattern from the net used in the filter often appears in the final captured image.

Another option available to the digital photographer in the field is to combine various camera filters for compound results. For example, using a graduated neutral density filter in combination with a soft focus filter. It is also interesting to combine two soft focus or diffusion filters for a compound effect. Then there is always the option to add a software filter effect later in the computer on top of the already filtered image from the camera. This approach of combining filters is an area for experimentation that really has no hard and fast rules, so don't hesitate to try as many combinations as you can come up with!

Portfolio: Employing Filters to Create Mood and Ambience

Most people spend the majority of their days in well-lit homes and workplaces, or outside in daylight. These conditions, therefore, represent what is considered normal, routine, and perhaps even mundane for some. Far more limited is the time spent under the extraordinary light of sunrise/sunset, dusk/dawn, or out in bad weather conditions. As a result, photographs taken under these unusual conditions (or photographs that seem to have been) represent something unique when compared to the sights we typically see from day to day. Colorcasts support certain emotional responses; a curtain of soft diffused light or the addition of film grain effects can be reminiscent of fog or mist; the wide range of available effects is fertile ground for producing something unusual.

"Architectural Study, Las Vegas": This was taken at sunset with a 300mm telephoto and a mist camera filter.

"*Wild Flowers, Late Afternoon Sun*": I shot this image with a 105mm lens and a combination of two soft camera filters. Then I used a Pixel Genius PhotoKit software warming filter.

"Dock in Early Summer Light": For this image, I used a weak Andromeda ScatterLight software landscape halo filter.

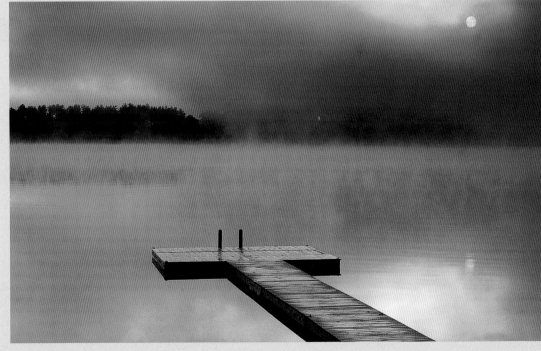

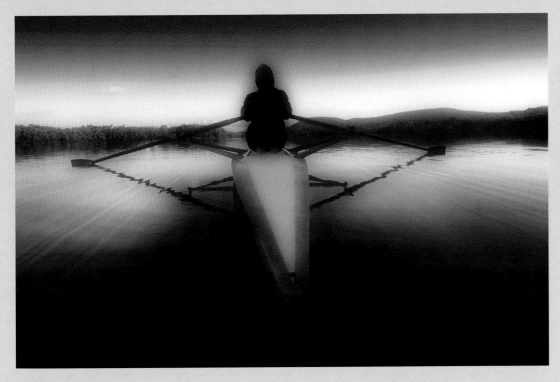

"Sculling on a Quiet Morning": I shot this image at 18mm, then used the PhotoKit software Burn-Tone effect for the sky and converted everything to monochrome and sepia tones. The soft focus effect and glow are from the Power Retouche PR-Soft Filter software program.

"Traffic at Sunset Under Rising Moon": This image was captured with a 500mm lens at ISO 3200, with additional grain added using Grain Surgery software. I also enlarged the moon by about 50%.

"Staircase, Victoria Railroad Station": This image was exposed at ISO 400 with a 28mm lens, and I combined Nikon Soft 1 and 2 camera filters.

Working with Long Aspect Ratios

6

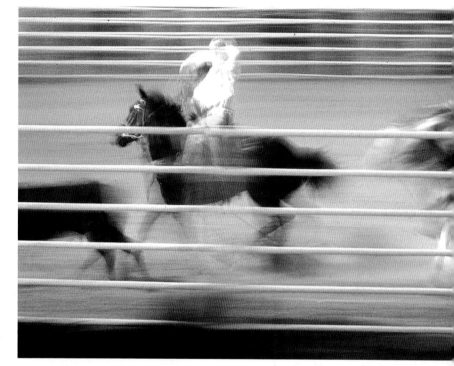

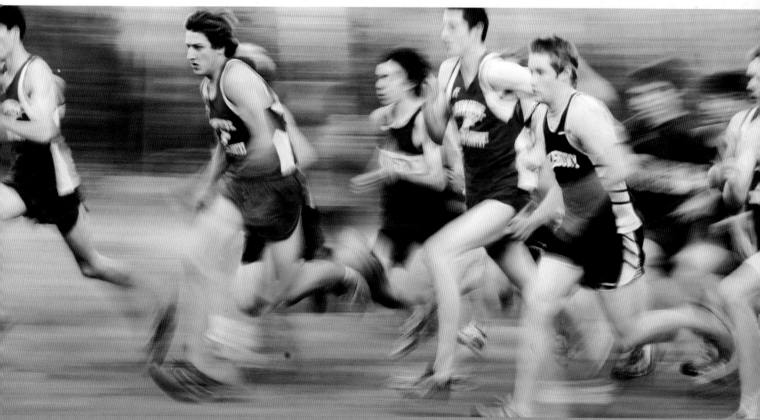

Panoramic photographs first appeared just a few years after the invention of the photographic process in the 19th century. They are characteristically long, narrow photographs taking in a very wide view without the distortions of an extreme wide-angle lens. The horizontal angle-of-view can extend up to a full 360°, although angles in the 100 – 150° range are far more common. The vertical-to-horizontal aspect ratio for panoramic images begins at 1:2 or 1:3 and can extend to as much as 1:10 or more. Most digital camera sensors, on the other hand, produce images with vertical-to-horizontal aspect ratios such as 3:2, and 4:3. Some of the most popular panoramic subjects over the years have been landscapes, cityscapes, disaster areas, and large groups of people, such as military units or high school graduating classes.

Digital Panoramic Photography

The simplest way to produce a digital photograph with a panoramic aspect ratio is to crop down the frame to at least a 1:2 or 1:3 aspect ratio. This will mimic the type of image produced by a non-rotational panoramic film camera. Taking this approach, however, significantly reduces the total amount of available megabytes placing limits on the maximum size for a good quality print.

To get the look and feel of a traditional rotation type panoramic photograph, the digital photographer must use a rotation movement; place your camera securely on a tripod and rotate it to take a series of single pictures through an arc up to a maximum of 360° (ideally using a level to be sure that the camera doesn't tilt as you rotate it). These pictures are then "stitched" together in the computer producing one continuous panoramic image. This can be done fairly easily using special stitching software that literally merges together overlapping single images to produce one continuous single image. Since several images are involved, the total file size can be substantial, providing plenty of megabytes for large prints. There is

also the more complicated stitched panorama based on photographing two or three parallel rows of images and then stitching them all together for a very large file. The camera is first titled up slightly for the series of left to right overlapping captures comprising the first row. It is then returned to the starting position and set parallel for the middle row of overlapping captures while also overlapping some of the first row. The camera is again returned to the starting position and tipped down for the third parallel row of overlapping captures with a slight overlapping with the middle row. Advanced software such as Stitcher by Realviz will then combine all three rows while making perspective corrections.

Thus, with the advent of panoramic software, one of the oldest and most traditional forms of photography has transitioned into the digital age. Furthermore, digital photographers are fortunate to have a long history of film panorama images to draw upon. Even so, as mentioned throughout the book, the creative digital photographer must seek to go beyond what has already been done and discover new forms of expression.

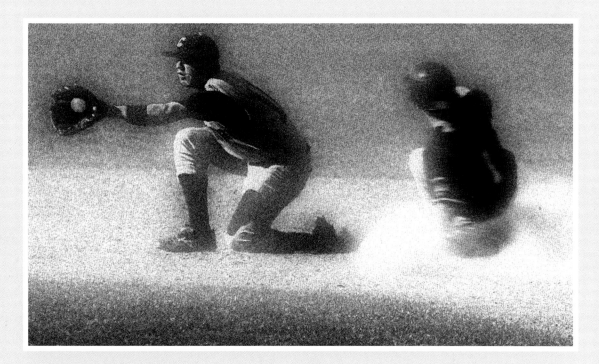

Why a Panorama?

The basic attraction of panoramic photography is that it captures the world differently than conventional cameras do, whether they're digital or film. The wide and narrow panoramic view enables the photographer to capture an extended scene without employing an extreme wide-angle lens and the distortion that goes with it. Panoramas are most often created along a horizontal plane, though vertical panoramas are also possible (see page 147). Interestingly, the typical horizontal panoramic aspect ratio of 1:2 or 1:3 is closer to the human plane of vision than the common rectangular capture formats of film and digital photography. This is because humans see much more on the horizontal plane than on the vertical plane. Specifically, a single eye has an approximate horizontal angle-of-view of 140° and a 90° angle-of-view vertically. With both eyes focused on a point directly ahead, a person can still see both hands extended directly out to each side at about 180° from each other.

The areas at the far left and far right corners of human vision are, however, not perceived with the same high degree of acuity as the more central sections. These edge areas make up that segment referred to as peripheral vision. To see peripheral areas in detail requires turning the head to the left or right, thus mimicking the rotation of a panoramic camera. Most photographers have trained themselves to concentrate on the center part of their vision, composing within the confines of a rectangular or square format. Part of that training includes learning to exclude extraneous visual elements in order to concentrate on specific and well-organized compositions. Panoramic photographers, on the other hand, train themselves to sweep the horizontal or vertical plane and organize what is there into a single picture. Consequently, the first step in composing a panorama is to look at the world with a panoramic view and learn how to compose within this elongated framework.

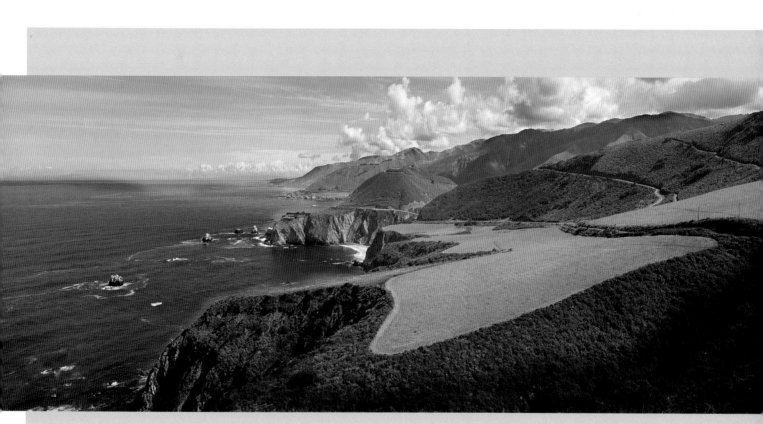

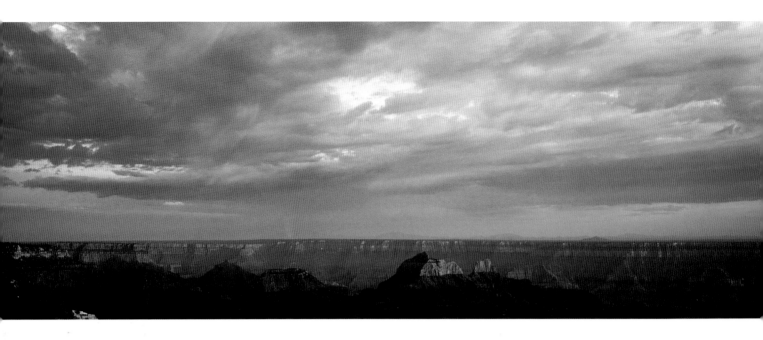

Panoramic Composition

Because the panoramic photograph is arranged along a long, narrow continuum (most commonly along a horizontal plane), some of the compositional approaches used with conventional formats are not applicable. For example, conventional format landscape compositions usually avoid placing the horizontal line in the center of the image. In a panoramic image, however, the horizon is typically placed dead center. This is largely because the horizon line acts as a point of organization along which are strung the individual elements of the whole composition. Also, in the case of photographs based on rotation, the horizon line has to be in the center since tipping the camera up or down will cause a

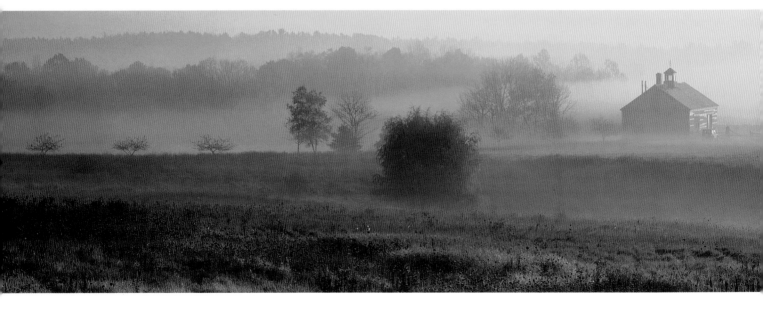

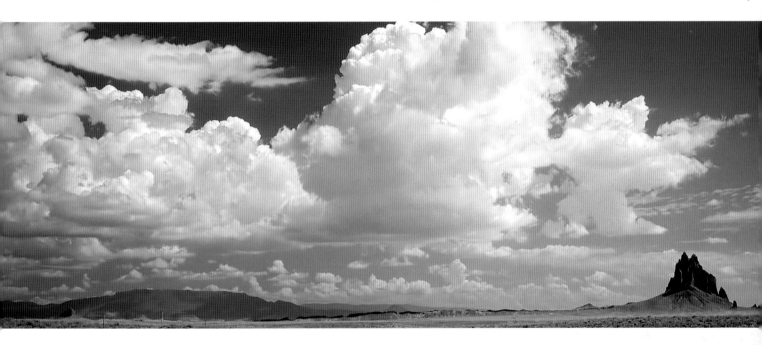

bending of straight lines. The use of negative space is also a limited concept since the idea of the panorama is to gather up elements that are spread out. In fact, the key to a successful traditional panoramic photograph is usually to unify elements along the extended plane. In summary then, panoramic composition is very much about establishing unity in the perception of a viewer who is used to seeing the world within the limitations of peripheral vision. This is the key to using the panorama approach and why it is so different. It allows the viewer to see a much wider view of the world with detail and clarity, all in a single picture.

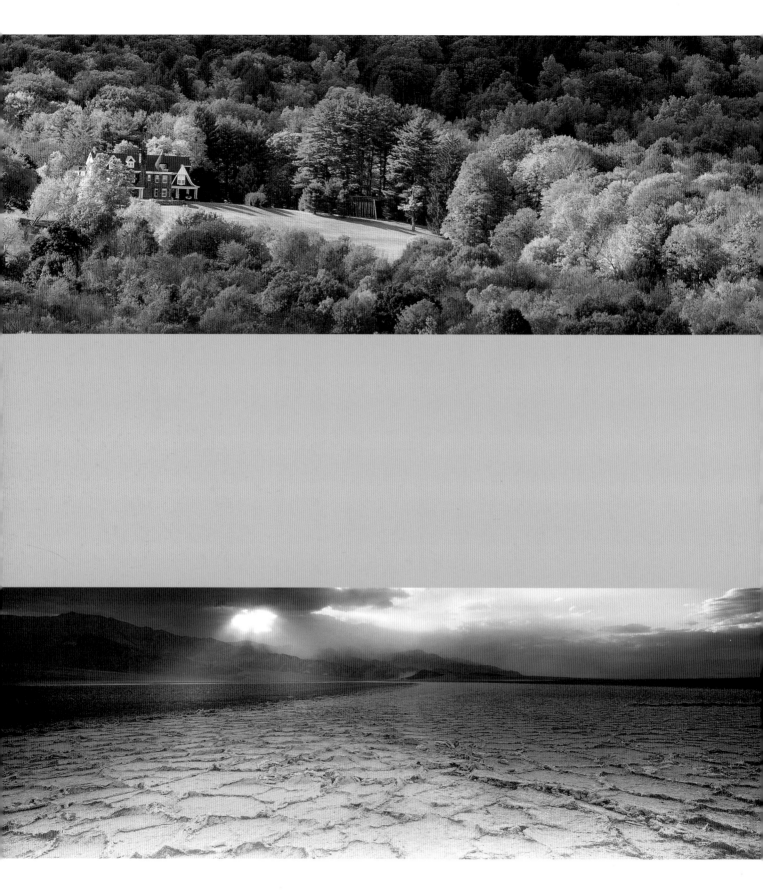

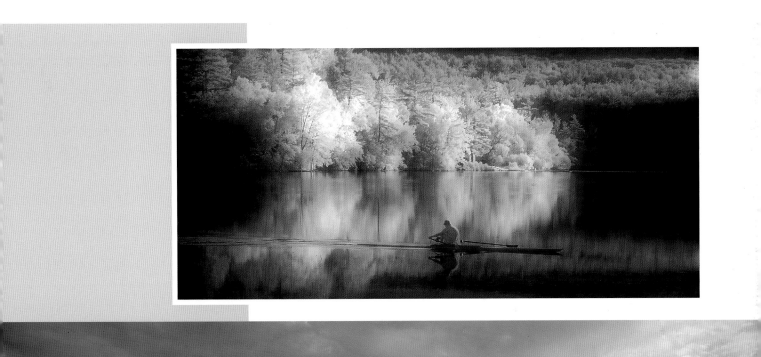

The traditional panorama is one in which all subject matter appears natural in terms of proportions, avoiding the distortions that would occur if a extremely wide-angle lens were used to try and take in the same angle-of-view. This is not to say that panoramic images, particularly rotational panoramas, do not produce distorted subject matter. On the contrary, as previously noted, if the camera is not level during the rotation it will cause the bending of horizon lines. Furthermore, as the rotation occurs, the distance between the various subjects and the camera changes. This means that the relative size of subjects will be different since the effective focal length of the lens is changing as the distance changes. (This can be seen on page 20 in the seascape picture where a relatively straight line of water in the foreground has been bent and recorded as a curved line due to the arc of the lens as it rotated.) This will occur even with the camera set level and parallel to the subject. Increasing the distance from structures with straight lines decreases the likelihood that such irregularities will be obvious or even detectable. On the other hand, knowing how the rotation movement affects a scene can be exploited.

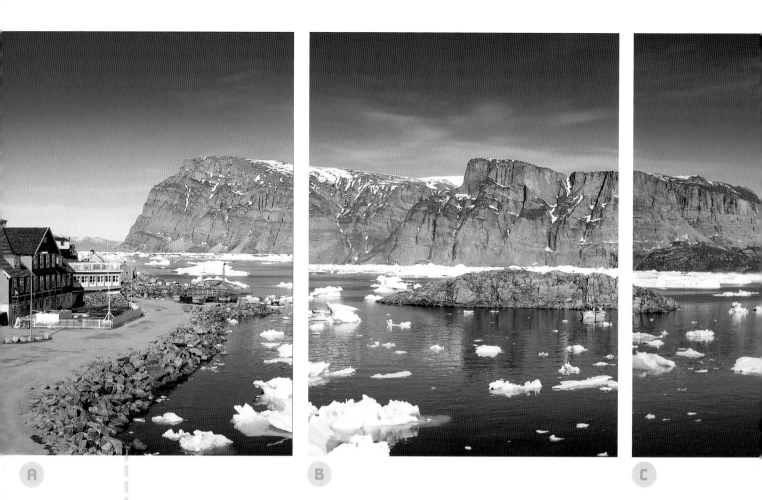

A B C

Creating a Rotational Digital Panorama

The technical requirements for producing a rotational digital panoramic photograph can be as freewheeling as handholding the camera to make a series of sequential photographs or as sophisticated as using a panoramic tripod head. In addition, there are two basic ways in which a rotational photograph can be presented. In the first form, individual but separated pictures record separate sections of the whole scene, as in examples (a) through (e). That is, each picture ends where the next begins separated only by a thin border as seen in (f). Thus, a complete picture of the whole scene is presented to the

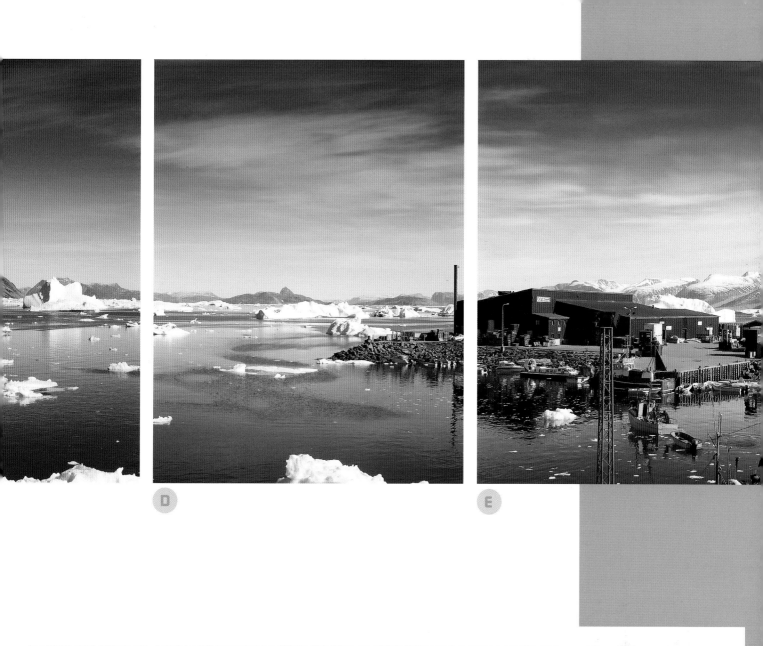

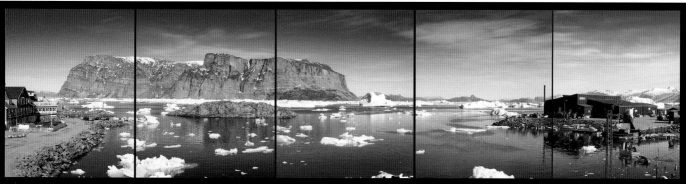

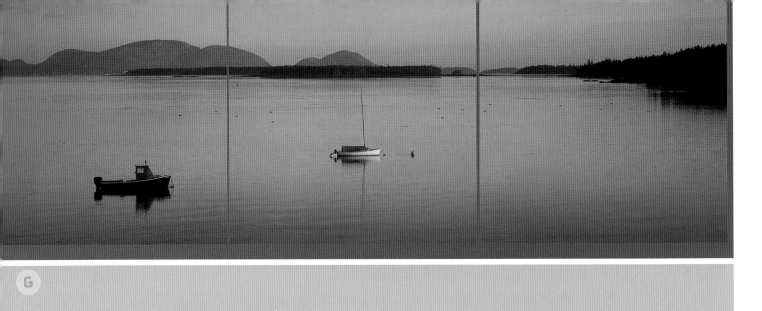

G

H

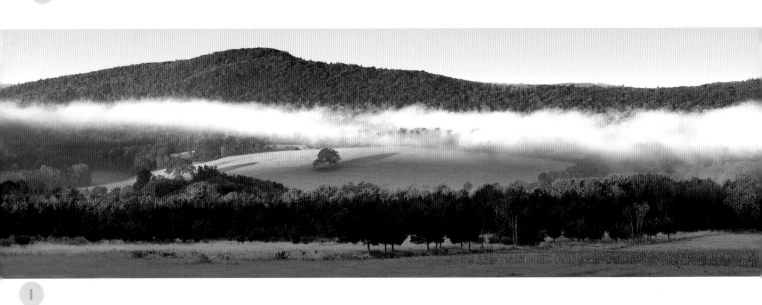

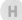

viewer, but in sections that are so close together that they give the impression of a continuous single picture. Example (g) is also representative of this technique. Sectioned panoramas are easy to produce and do not require any stitching software. These images can be created using a range of lens focal lengths. They also offer many opportunities for creative variations, such as altering the size of some of the individual images as seen on page 145 at the end of this chapter.

The second option is the "stitched panorama," consisting of a series of overlapping pictures that are then assembled into one continuous and blended image in the computer. These pictures are more difficult to produce, requiring greater care when taking the initial pictures, as well as later in the computer. If done carefully, however, one would be hard pressed to tell the difference between a stitched rotational digital photograph and one taken with a rotation panoramic film camera. A field of view up to 360° is certainly possible using a digital camera and stitching software, but many photographers will capture smaller arcs, typically in the 100 – 150° range. Example (h) was assembled from a group of overlapping pictures of the harbor scene using image stitching software. Example (i) was created using the same technique on a different location just after sunrise.

The Nodal Point

When a camera is rotated to produce a panoramic image, the most desirable way to do this is to make sure the camera is rotating around the nodal point of the lens. The nodal point, or lens center, is that point at which the camera can be rotated without changing the relative distances between objects and the camera's sensor. This avoids misalignments and stitching errors. The problem is that, when cameras are mounted on a tripod, the location of the mounting point on the bottom of a typical digital SLR body usually is not at the lens nodal point. The effect of this form of misalignment is critical when dealing with objects within a few feet of the camera, but becomes negligible for distant areas and ones with diffused structures such as natural landscapes (as opposed to buildings).

Panoramic Procedure

The general procedures for producing both the sectioned and stitched digital panorama are as follows:

Level Camera: The most critical technical requirement is to have the camera set level from the first to the last picture. It is possible to produce a panoramic image by either hand-holding the camera, using a tripod with a simple rotating mechanism, or by using a specialized panoramic tripod head. Using a tripod with a bubble level installed in the camera's accessory shoe is a much more exact and controlled method than the handheld approach. On the other hand, a handheld panorama will often have a different look with its own appeal. The use of a specialized panoramic head is the most exacting approach. It will not only keep the camera level, it will also keep the camera revolving around the lens nodal point (see page 139 for more information).

Exposure: One of the problems with panoramic scenes is that they usually take in such a wide area that the chances of exceeding the exposure latitude of the digital sensor are increased. The easiest way to avoid this is to select a scene in which the lighting ratio between highlights and shadows does not exceed 5 stops. Determine the exposure as if photographing the whole scene as one picture. Place the camera in manual exposure mode for this "one scene exposure setting" for all pictures.

White Balance: As different areas of a scene can vary in terms of light intensity, so, too, can the color content of the light. Setting a digital camera on Auto white balance may produce different color renderings in various segments. To avoid these variations, set the white balance to the light condition that most closely approximates the over all scene.

Focus and Aperture: Using the autofocus mode runs the risk of the camera seeking out different focus points in each picture. Set the camera in manual focus and (as with the exposure) consider the scene as one picture while setting the focus point accordingly. It is also best to select an aperture with enough depth of field to keep everything in sharp focus.

Lens Selection: While it may seem that a wide-angle lens is a logical choice for a panorama, a normal lens or a moderate telephoto are actually better choices. These lenses are less prone to distorting subject matter at the edge of the field or in the close foreground areas and will tend to give a more natural representation. Remember, the wide field of capture is actually coming from the rotation of the camera, so it doesn't need to come from the lens.

Camera Orientation: Select the orientation of the camera (horizontal or vertical) based on the subject matter. The horizontal recording has the smaller height so the final picture will be narrower than if the vertical position were used. Also, since less vertical area is covered in each photograph, more images will have to be taken to capture the whole scene.

Filters: Polarizers are often used in landscape photographs because they intensify blue sky areas, but in the case of a panorama, the wide field will likely take in areas not effected by the polarizer filter. This will tend to exaggerate the difference between these two areas, and the result can be a very uneven sky color. Graduated color and neutral density filters also have to be used with care since they introduce a definite effect into the sky area that may not appear continuous from frame to frame. The best approach here is to take two series of shots—one with and one without the filter—and compare the results. Graduated and polarizer effects can also be added later in the computer after the single image is assembled using the software options detailed in the last chapter.

Picture Sizes and Overlap: In the case of a sectioned panorama, the usual practice is to make sure that the final frame size is the same for a uniform appearance across the whole field of view. This is the case if your aim is to have the illusion of one continuous photograph separated with thin borders. Some of the creative examples in this chapter, however, deviate from this guideline for their own effect. Still, this is the best scenario to start with even if the plan is to do some sort of variation. Resizing can be done in the computer. In the case of stitched panoramas, there must be some degree of overlap from picture to picture so the software can align the images. The amount will depend on the stitching software. Typical recommended overlaps will vary from 30 – 50%. This overlapping is done in the camera viewfinder by selecting a landmark in each frame and rotating the camera to that point for the next shot.

File Format: Selecting a file format can be very critical to the final blending of the image. The preferred format for initial capture is the camera's RAW file, as it gives excellent control over exposure, contrast, brightness, white balance, and other key qualities. If corrections are made, they must be applied uniformly to all frames in the sequence. Then, save all images as TIFF or JPEG files in preparation for use by the stitching software (unless the software can process RAW files). The best image quality comes with 16-bit files, but many stitching programs cannot process 16-bit and will require a conversion to 8-bit.

Post Processing: While it is possible to achieve excellent results with stitching software, it is not unusual to have to make some post-stitching adjustments. There is also the opportunity to introduce other effects to the whole image, such as color corrections, color graduated filter effects, and soft focus.

Scene Stability: Remember that a digital panorama, unlike images taken with a film panorama camera, will not capture everything in the scene in one exposure. Thus, moving objects will present a problem for the digital panorama.

A

B

Portfolio: The Panoramic Crop

Any image can be transformed to show a panoramic aspect ratio; simply crop it so that one side is at least twice the length of the other. The key is to make sure that the most interesting part of the captured scene is occurring within the middle third or so of the frame. Technically, this is not a panoramic image but rather the use of the panoramic aspect ratio. Also, the crop may or may not take in a wide panoramic view as opposed to simply a tighter composition of a normal or telephoto focal length.

Example (a), taken from a moving car at sunset, is an example of this narrowing of the frame. The picture is all about the ribbons of roadway and the cars moving in both directions. Originally captured on a D-SLR, the image was cropped down so that only the key subject matter was included, excluding a weak sky area. The 1/60 second shutter speed was fast enough to render cars moving in the same direction as the camera sharply while slightly blurring the oncoming traffic, adding to the sense of movement. A 180mm focal length compressed the view of the traffic in the scene.

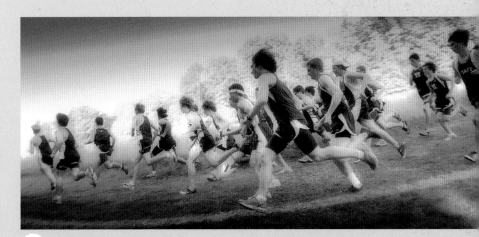

C

The same efforts to isolate key components and use the focal length for compression effects were employed in example (b), but the effects were even more pronounced as a result of the extreme crop of a D-SLR image taken with a 400mm lens. In example (c), I used an extreme wide-angle 18mm lens held close to the passing runners from a low perspective then applied a panoramic crop. The curvature is the result of the extreme wide-angle lens used close to the subjects, yet it looks like it may have been taken with a swing lens panoramic camera. A moderately fast 1/125 second shutter speed renders the subjects relatively sharp but still with just the slightest blurring to give the illusion of movement. The image was processed using Auto FX software; I selected an "Antique Photo" treatment. Compare that with another group of runners in example (d),

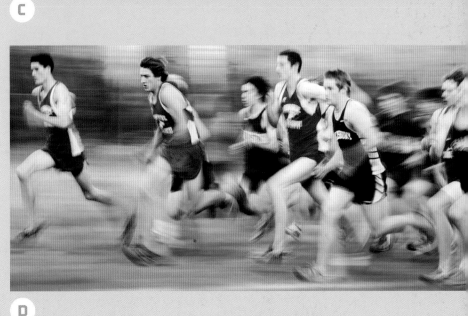

D

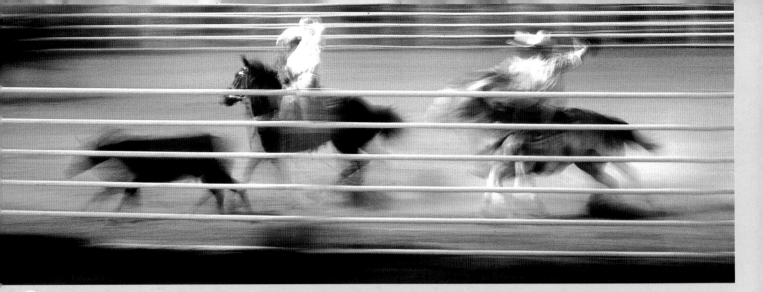

E

captured from a distance with a 200mm lens and a pan blur movement at 1/20 second shutter speed. For the rodeo riders in example (e), I used an even slower 1/4 second shutter speed. I applied a panoramic crop to both images.

Panoramic cropping also opens up a number of different possible framing presentations, such as the use of several pictures showing the parts of a sequence all within a sectioned panoramic composition. Each photo is separate, but part of a complete sequence. In a typical action photograph, the photographer will shoot a series of pictures that actually capture a whole event, such as the scoring of a goal. The end result, however, is usually just one picture. The long narrow continuum of the panoramic aspect ratio, on the other hand, allows several of these pictures to be placed within the elongated frame to show the beginning, middle and the end of a sequence, as in example (f).

F

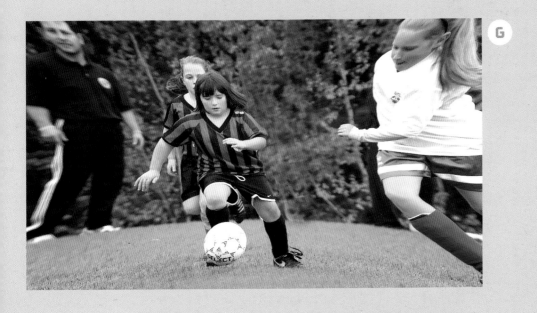

G

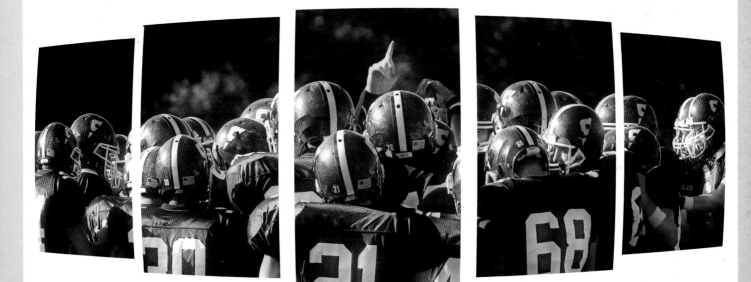

H

Still another variation is to photograph one subject at different magnifications. In example (g), I employed this technique by first cropping down an action shot of a youth soccer game. Then, using the effect of barrel distortion in the Grasshopper Image Align software program, I distorted and enlarged the size of the player at the corner and the person in the background. In example (h), the football shot in example (b) was cut up into a sectioned panorama and the different windows enlarged toward the center using the Grasshopper Image Align software Pincushion Correction/Distortion tool.

© Donnette Largay

In example (i), I superimposed a film frame template from Auto FX software over a rotational digital panorama done with a handheld camera. This helped to mask the imprecise match up between the segments caused by handholding. In example (j), the individual images of Canyon de Chelly in Arizona taken with a D-SLR and a 120mm lens were first given a Soft Edge Vignette of 12 pixels using Pixel Genius Photo Effects software, then dropped into a black background at different angles. Finally in example (k), Donnette Largay's telephoto dramatic capture of back lighted horses and riders is an excellent example of a scene in which the main elements are silhouetted and framed within a panoramic crop.

Portfolio: The Vertical Panorama

The vertical panorama is far less common because its tall, narrow form fits only a limited number of specific subjects, such as tall buildings, waterfalls, trees, and near to far compositions such as the ocean to the sky. In the first frame of the composite of four examples, the long rows of steps leading up to the buildings have a curvature caused by the rotation movement which produces a striking and dramatic composition. A weak solarization effect was added using nik multimedia software Color Efex Solarization filter. In the next image, the vertical framing ties together a close-up of a tidal pool with the open ocean and a strong sky area. The same composition is working in the third image in from the left, incorporating a side-lit close-up of a salt flat with a distant mountain range at sunset. Finally, in the last example, the serenity of dusk is reinforced by the wide expanse of a magenta-blue sky above a distant mountain range. All four compositions force the viewer to concentrate on a thin segment of a larger scene in an unusually wide angle-of-view. This presents subjects in a much more focused way than might have been possible with a wide horizontal view.

The Impact
of Weather Conditions

7

Some of the most dramatic photographs ever taken have been under extraordinary, if not spectacular, weather conditions. Such atmospheric displays as majestic white thunderheads rising against a dark threatening sky, or the veins of corpuscular-like light rays puncturing through layers of clouds at sunset, certainly can add dramatic effects to any outdoor scene. Then too, there are those circumstances when the weather introduces or supports a definite mood and ambience to a scene. For example, the serenity of a descending curtain of thick fog or the gentle flakes of snow slowly accumulating in soft white layers over the landscape. In short, weather, in all its permutations, can provide natural light photography opportunities that are truly unique. However, with such unique opportunities comes a unique set of challenges. In particular, many of these atmospheric conditions last for just a few minutes, while others may go through different phases over a short period of time. The transitory nature of weather means that you have to be ready to capture them at a moment's notice, not only with camera and equipment, but also in terms of anticipating what settings will yield the best results under specific conditions.

This chapter concentrates on exploring some of the photographic characteristics associated with weather conditions. The goal is to alert you to the opportunities presented by these various conditions, and to offer some suggestions on how to deal with the challenges to make the most of each opportunity.

Weather Information

Perhaps the most difficult factor related to weather conditions is that kind of detailed information that would be most useful to the photographer ahead of time is not routinely available. For example, the official weather forecast for the next day may include fog but the specific type of fog is not usually designated. That is, will it be a curtain of heavy fog or will differences in air temperatures produce layers of "pancake-like" fog that will hang between the hills of a distant landscape? The forecast might also include a prediction of a partly cloudy day, but what kind of clouds? Cumulus? Cirrus? Stratus? Or perhaps nimbus clouds? Will they be high level, mid-level or low level clouds? The answers to such questions are not normally a part of routine weather forecasts, as such specific predictions are very difficult to make. The bottom line is that each day can bring surprises as well as disappointments. So, as every natural light photographer learns, you simply have to be there to see what is going to happen.

Then there is the challenge of trying to determine the best subject for a particular weather condition. What is it that would be rendered in an especially interesting way, and under which atmospheric conditions? For example, since fog diffuses light, the best subjects are ones that have strong shapes and lines, as opposed to softer subjects whose physical makeup can become completely lost in diffused lighting. In many cases, this is something that can be scouted out ahead of time so that you can estimate an effect. In fact, one of the most useful practices for a landscape photographer is to scout a location and estimate the effect of various types of light (sunset, dawn, midday light, etc.) as well as different weather conditions (such as fog, an overcast day, snow, or haze).

Weather as a Light Modifier

Determining which subjects might work with what weather conditions is a function of the way a particular atmospheric condition affects natural light. Each type of weather will operate as a light modifier, similar in some cases to the light modifiers found in a photographer's studio. Here then, is a summary with illustrations of the key characteristics of various weather conditions.

Fog, Mist, and Haze

Fog, mist, and haze are made up of tiny suspended water droplets that scatter sunlight, reducing visibility to different degrees. There is also a noticeable loss of contrast accompanied by a softening of details. Generally, fog reduces visibility the most, as in example (a), followed by mist, seen in example (b), with the least dense of the three being atmospheric haze, illustrated in example (c). In heavily polluted areas, such as in example (d), suspended solid particles will add to the lowered visibility, and may contribute weak color as well.

Fog occurs when the dew point of the air and the air temperature are about the same. In general, fog presents photographers with the most opportunities because of its varied forms and its more pronounced effects. There are plenty of literary references to the emotional effects of fog, from Homer to Shakespeare to Sherlock Holmes, as well as in modern parlance. The references usually revolve around how fog disrupts our ability to see the world clearly, or they emphasize how fog adds a sense of mystery or foreboding. Fog can easily give the visual impression of an ethereal world in which the usual structures are rendered so soft as to appear suspended in an otherworldly environment. The single tree that emerges out of the fog or the house shrouded in fog is stripped of its normal setting as if existing in a dream state.

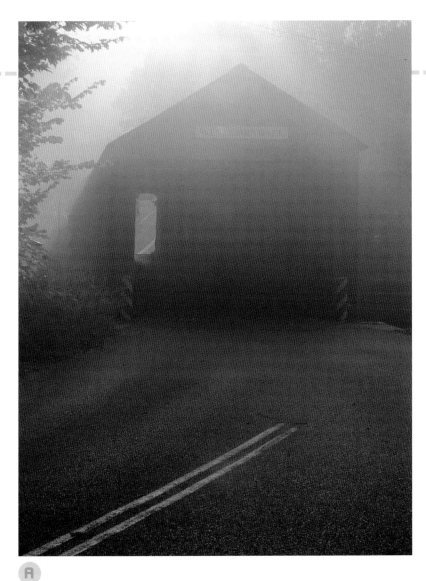

A

B

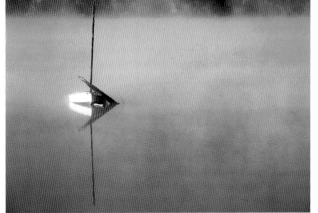

C

D

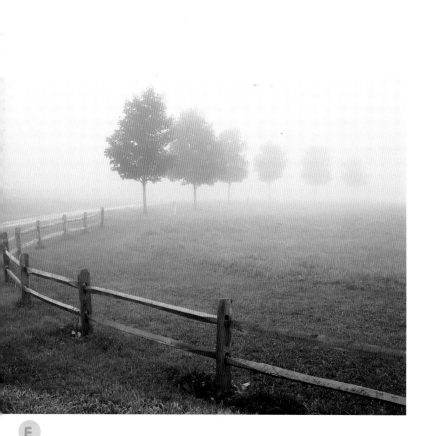

E

In addition to these emotional aspects, a generalized fog condition such as frontal fog (see the following page for details) is also a very useful camera tool. As the distance to the camera increases, more and more water vapor builds up reducing the clarity of objects far from the camera, as seen in example (e). This is an effect somewhat similar to a decrease in depth of field as the aperture opening becomes larger. Unlike depth of field changes, however, the effect increases as subject distance from the camera increases. Thus, fog is a very effective way of getting rid of (or at least mitigating) unwanted backgrounds while giving more prominence to the foreground. In short, fog has the ability to simplify the complex and reduce a scene to its strongest elemental features, which are those closest to the camera, as seen in example (f). In scouting a location, try to identify interesting subjects that, under foggy conditions, would be isolated from busy and distracting backgrounds. One of the drawbacks of working in foggy conditions, though, is the loss of light. If the fog is quite heavy, light loss can be between 2 – 4 stops, and sometimes even more.

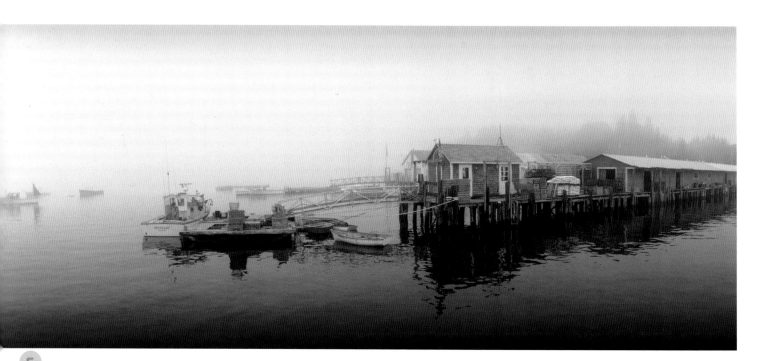

F

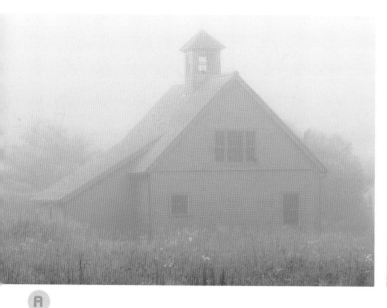

A

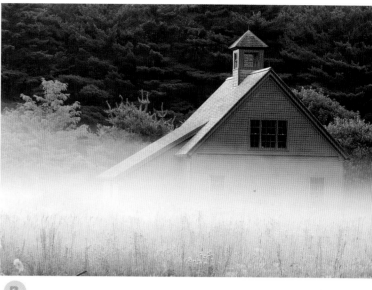

B

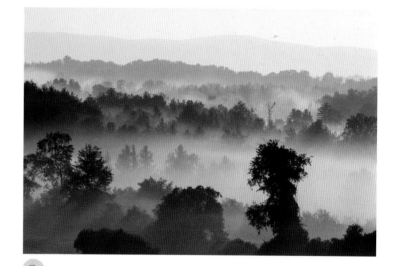

C

Common Forms of Fog

Meteorologists categorize fog according to the physical conditions that cause it. For example, frontal fog is caused by the arrival of a weather front, usually a warm front that causes the evaporation of water into tiny droplets. This is the curtain of fog that descends completely over a scene, as seen in example (a). It is this form that characteristically produces the loss of background as the distance from the camera increases.

Ground fog, also called radiation fog, is a shallow layer of fog that hovers near the ground caused by the radiational cooling of the earth in the evening, as seen in example (b). This form of fog helps separate out ground contours, as seen in examples (c) and (d), or hide low

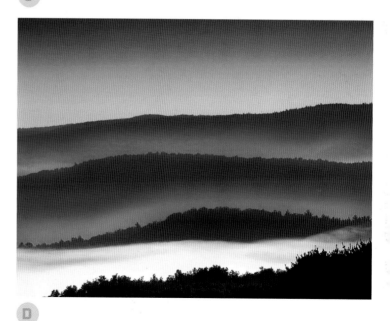

D

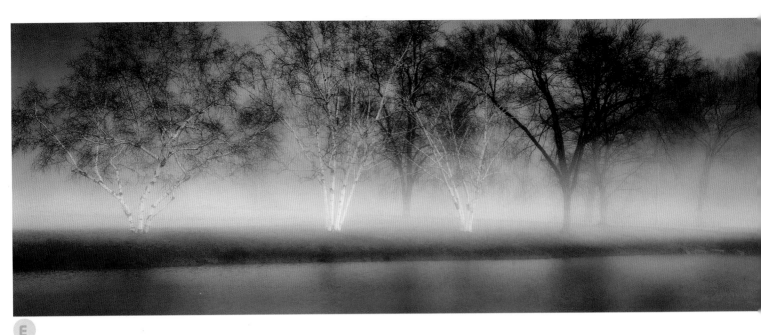

E

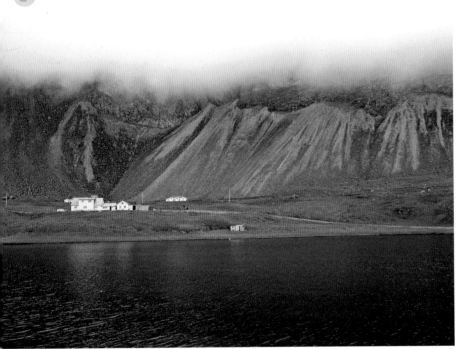

F

immediate background areas just behind the main subject in tighter compositions, as in example (e). Steam fog, or sea smoke, is yet another form. It appears when a layer of cold air arrives over warmer water, and is most common at sea or off shore where the fog forms a low-lying bank. This is the fog that seems to swallow the sun just as it approaches the horizon, as seen on page 163 at the end of this chapter. There is also the type of fog that seems to hang over the ground, illustrated in examples (f) and (g), sometimes forming a tube shape. This is caused by local differences in ground and air temperatures that keep the fog mass from settling or diffusing across the land.

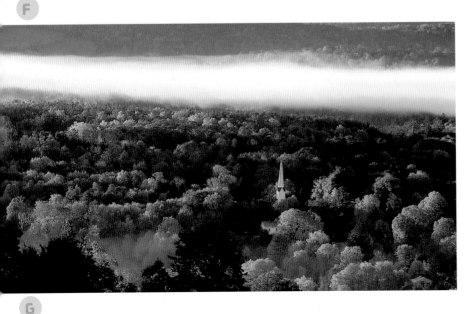

G

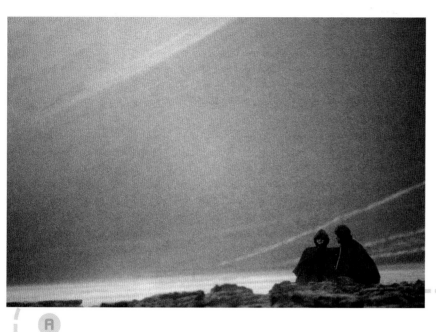

A

B

C

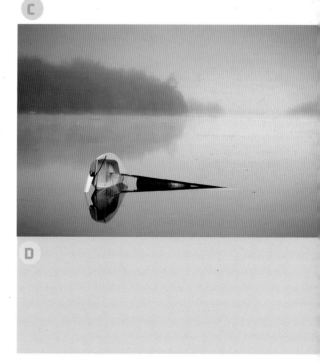

D

Rain

Of all the weather conditions you can take pictures in, rain is the least desirable. It represents a danger to your photography equipment, and rain splatter on the lens can spoil the clarity of your pictures. Like fog, mist, and haze, rain conditions are accompanied by a great reduction in contrast due to the scattering of light, with all but the brightest colors appearing muted. Example (a) shows a scene where the rain is so heavy as to produce a very gloomy atmosphere. If you can photograph from a protected location such as a car, the window of a building, or under an umbrella, you will have many more possibilities for different renderings of a scene. The key is to locate subject matter with strong lines and strong colors that will survive, to some degree, through the diffusing effects of rain droplets, as in examples (b) and (c). If a slow shutter speed is used, such as 1/10 second or slower while handholding the camera, it is also possible to portray the rain as a texture across the whole picture. If you happen to be there as the rain lets up, a very interesting moment to capture is the period just after the rain stops and a mist-like aura remains, sometimes for just a few fleeting moments, as in example (d).

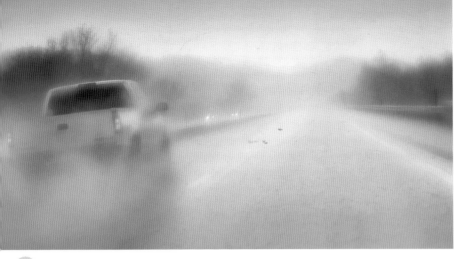

One neat visual effect that rain consistently has to offer is that flat surfaces such as roadways will give off a reflected light sheen, adding a degree of contrast to the scene. This is especially true of nighttime scenes, or at dusk, as is so often seen in car advertisements. Then there are those times when a spray of rain from a moving vehicle covers the scene in a blanket of moisture, as in example (e). Another opportunity occurs just after a rain when the wet bark of trees appears black and the shimmer from wet leaves adds to an otherwise flat scene. As pointed out earlier in the book, a polarizer filter is especially effective at reducing the glare off of leaf surfaces to allow for a more saturated appearance of colors without affecting the black bark.

E

F

Still another opportunity rain offers is to photograph the individual elements of rain. Rainbows, for example, as seen in example (f), or the sheet-like appearance of a scattered rain shower as it moves over a distant landscape, as in example (g). Be aware, however, that a polarizing filter will eliminate or greatly reduce the presence of a rainbow. Other opportunities are offered by reflections in puddles, or the display of raindrops across a smooth surface such as on the hood of a car.

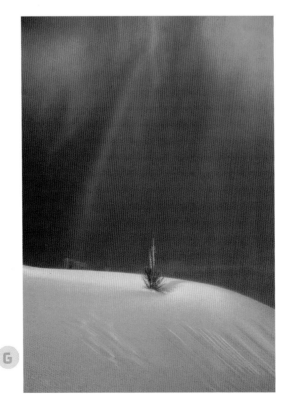

G

Snow

Photographing snow scenes is a challenge for both photographers and their equipment. One of the main reasons for this being that cold temperatures bring on human discomfort as well as stress to equipment, particularly batteries. Also, like rain, there is a risk of camera equipment getting wet and droplets forming on the lens front. In addition, moving from a warm to a cold environment can produce condensation that will freeze on the camera body and lens. A common practice to avoid this is never letting the camera equipment warm up too far above the working environment.

In addition, adjustments have to be made in metering scenes that are often made up of white on white layers. Even the most sophisticated camera meter can be fooled into underexposing such a scene. The problem stems from the fact that all camera meters will render what they "see" as middle gray. That is, the meter will select a combination of aperture and shutter speed that assumes the brightness of the scene averages out to the same settings that would correctly expose a middle gray card. Thus, the photographer must adjust most snow scenes by adding between 1.5 and 2 stops or more of additional light to prevent the snow from being rendered as middle gray. This is easily done by adjusting the exposure compensation setting on the camera for this amount of additional exposure.

The appeal of a snow scene will depend to some degree on the nature of the subject matter. That can vary from the serene mood of a snow-covered landscape to the drama of a speeding downhill skier. The common factor is the white mass that acts like a shroud over shapes and forms. At times, this works to the advantage of the photographer, allowing for the complete isolation of a subject against what is for all intents and purposes a plain almost colorless background, as seen in examples (a) and (b). The key to seeing these shapes and forms is the quality of the light and its direction relative to

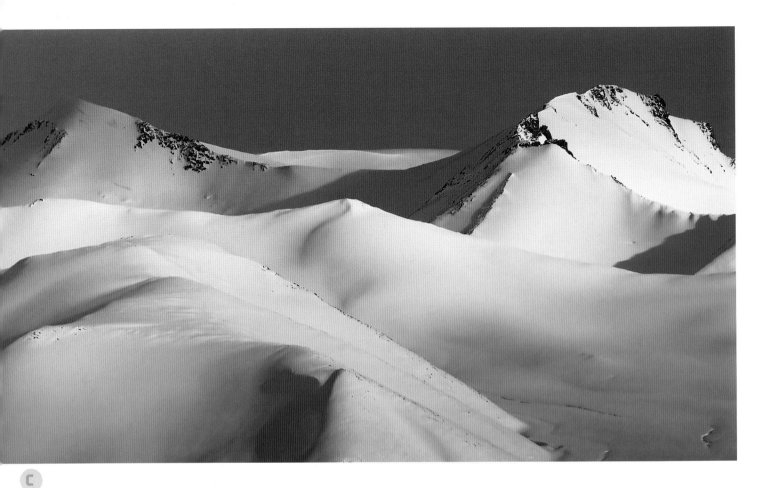

D

the subject. Evenly illuminated scenes on overcast days, for example, will often lack shadows. This results in a loss of shapes and forms, and offers no real sense of depth. Side lighting can play a major role in disclosing depth, shape, and form, as well as textures, as illustrated in example (c).

Various combinations of snow, light quality, and skillful use of camera tools in various combinations can deliver a wide range of atmospheric moods with snow scenes. For example, a slow shutter speed during a snowstorm will emphasize the snowfall itself, as seen in example (d) taken at 1/5 second. A light covering of snow will deliver a highlight layer to a scene, bringing out details and shapes, as seen in example (e). The added bonus of ground fog, seen in example (f), will also sometimes appear after a snowstorm, adding an ethereal quality to the scene.

E

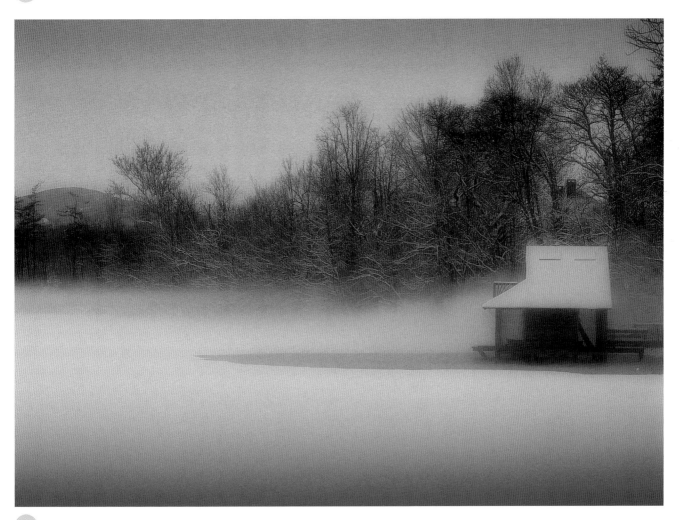

F

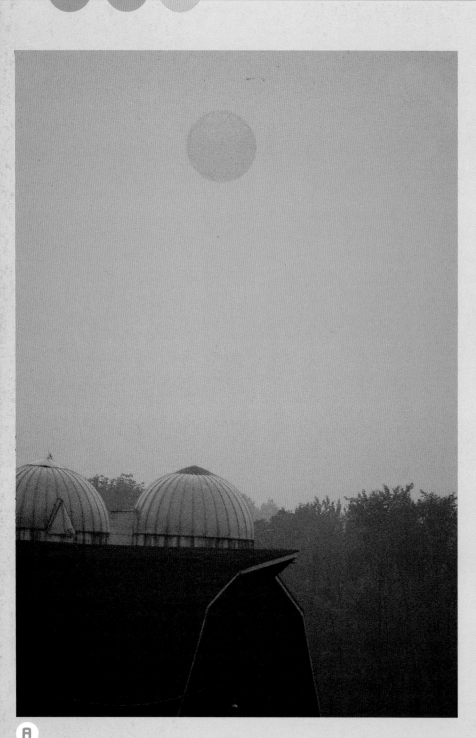

(A)

Portfolio: Shooting the Sun

The digital sensors used in today's cameras are designed to photograph reflected light as opposed to a direct light source such as the sun. Including the unfiltered sun in the picture will likely result in an overexposed white blob. There are, however, many times when the environment provides an effective filtering mechanism to reduce the intensity of the sun to recordable levels. The result can be the focused shape of a colored orb, or perhaps, some visual representation of the light in the form of corpuscular rays as shown in the examples here.

The most common environmental filters for holding back the intensity of the sun's light are fog, mist, and haze. Fog is the strongest filter, as seen example (a) where the fog is so thick as to render the sun as a deep orange orb above the barn silo and trees. Example (b), shot at ISO 800, offers a grainy rendering of a surfer walking toward the sun, while example (c) shows the sun being swallowed by sea smoke fog.

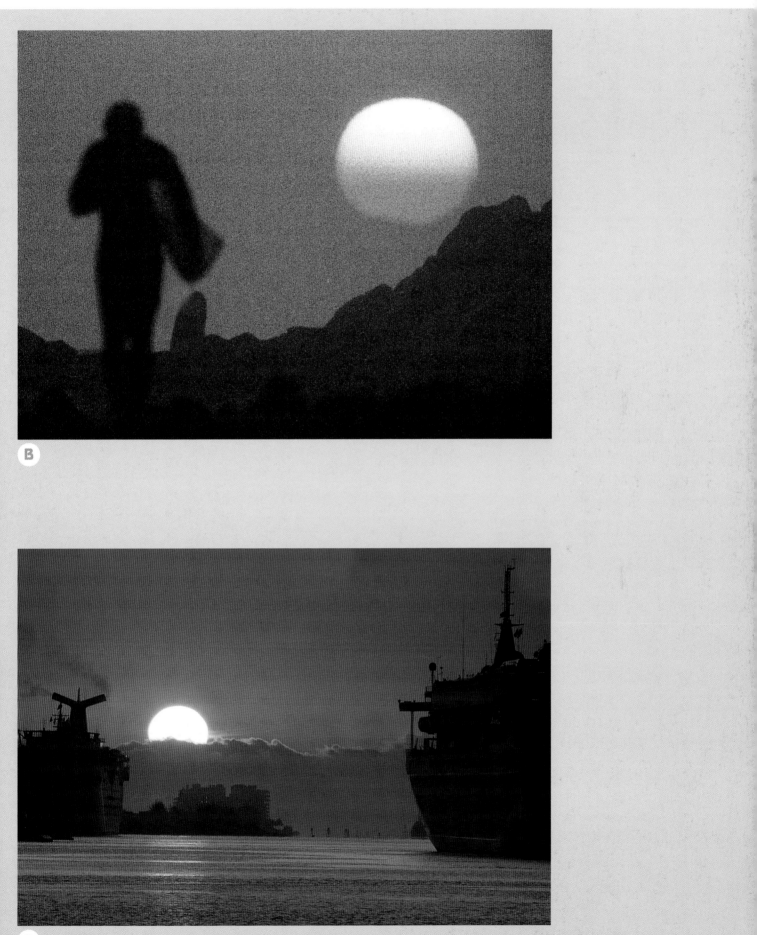

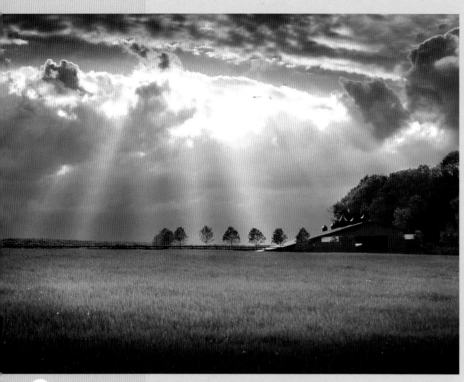

D

Using objects in the environment to block the sun in order to capture its rays of light is another technique. For example, when the sun is blocked by clouds and there is enough moisture in the air, corpuscular rays of light can occur, as seen in example (d). Fog conditions also frequently produce this effect, as in example (e) where a rising sun is positioned exactly behind the trunk and limbs of a tree during a lifting frontal fog. In examples (f) and (g), a misty atmosphere in combination with a line of trees gives an overall soft focus effect to the scattered rays of an early morning sun.

Far less common is the use of a manmade environmental filter, such as the tinted glass window in the beach house seen in example (h). Finally, with salt particles and moisture in the air near the surface of the ocean at the end of a hot summer day, there is enough scattering of the light from a setting sun to produce a vibrant orange orb, shown in example (i).

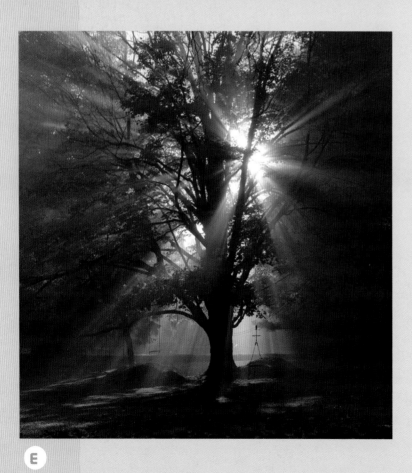

E

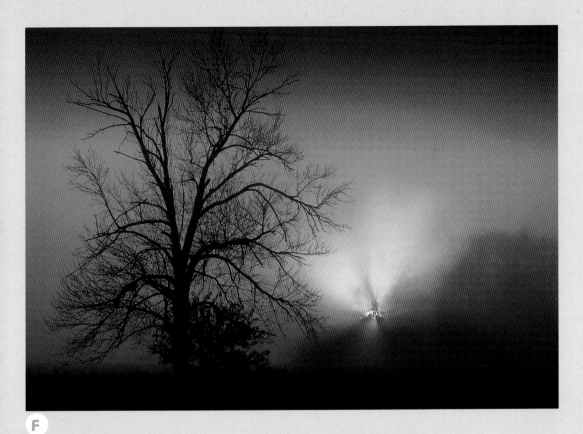

F

G

H

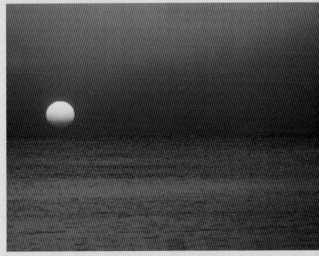

I

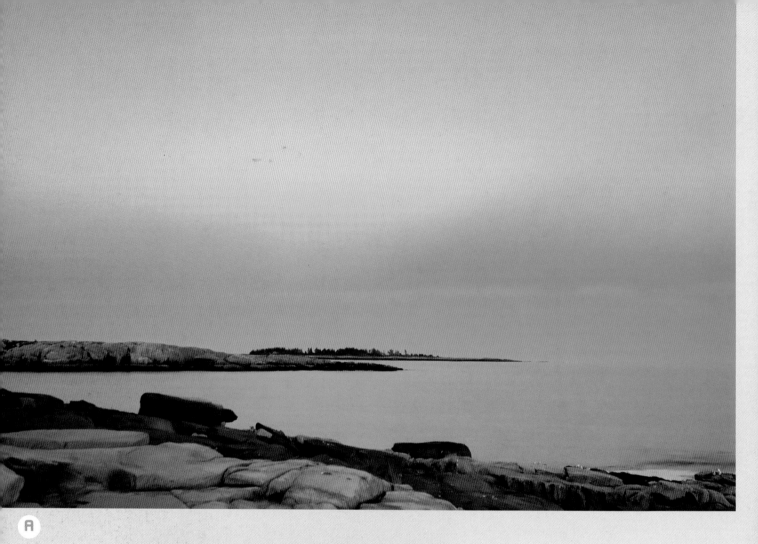

A

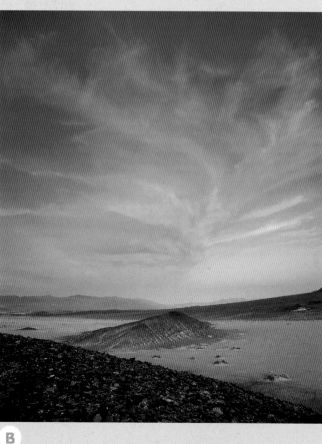

B

Portfolio: Dramatic Skies

Most landscape compositions contain signifi-
cant areas devoted to the sky. In many cases,
the appearance of clouds, a rising or setting
sun, and other atmospheric conditions will
add greatly to the mood and ambience of the
scene, as seen in examples (a) through (f). In
the case of a clear sky, the use of tonal grada-
tion with a graduated ND camera filter (or a
comparable function in image-processing
software) will add a variable level of contrast
to the sky. You can also use a polarizing filter
to deepen blue sky areas. At the very least,

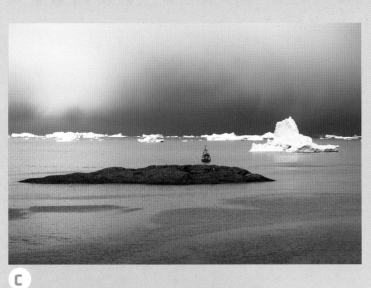

C

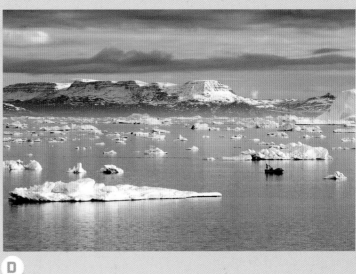

D

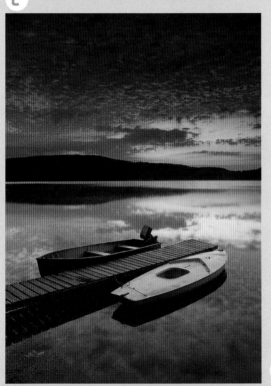

E

the sky forms a backdrop to the topography
of the landscape and can add an extra
dimension to your picture, so avoid overex-
posed or milky white skies that can detract
from the whole presentation. While filters
and computer software can be very effective
at helping the appearance of landscape skies,
many photographers prefer the variety of sky
formations that occur naturally, as seen in the
collage in example (g).

F

G

The Strange World
of Infrared Light

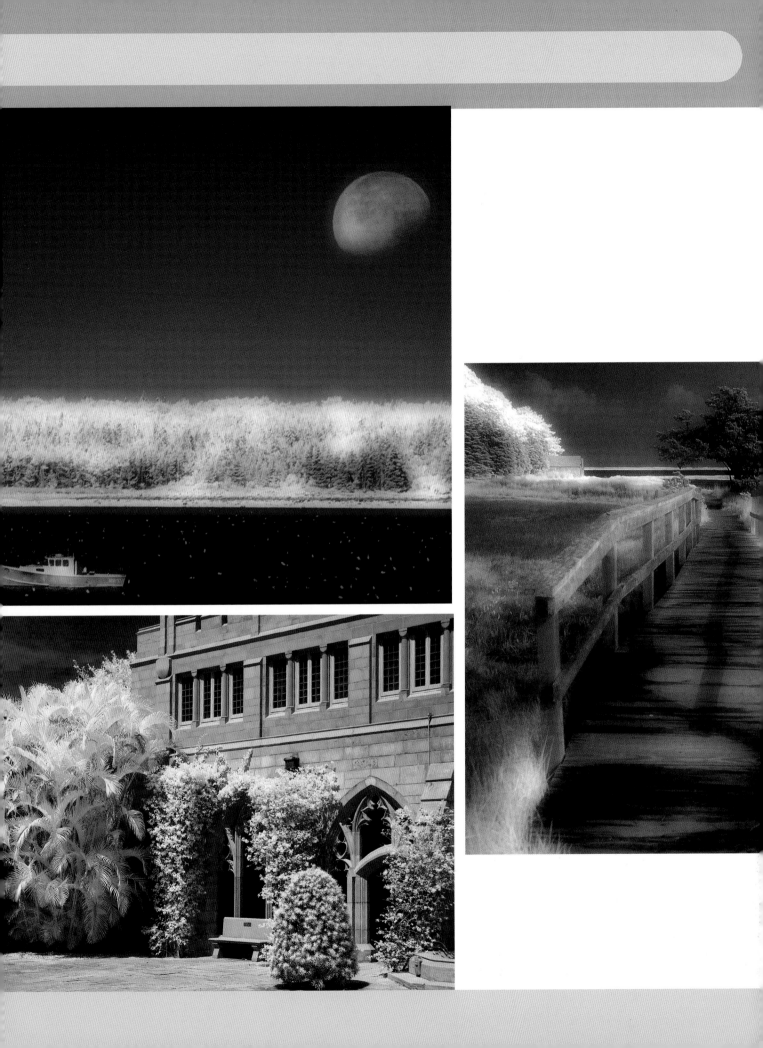

One specialized form of photography that has intrigued creative photographers for decades has been the capture of subjects with infrared light using infrared sensitive black-and-white films. Monochrome infrared film photography is, however, a tedious process carried out under completely light tight conditions. This includes loading and unloading the film from the camera and processing in absolute darkness. Digital technology has made producing infrared images much easier, while also offering more flexibility in the use of camera tools and techniques, as seen in the first part of this chapter.

The portfolios at the end of this chapter offer an examination of the personal vision of two photographers, Dan Burkholder and Theresa Airey. Both share a common bond as fine art photographers, but greatly differ in their use of specific tools and techniques, as well as in their individual motivations. The result is two very different views of the world as seen in their images and disclosed in the accompanying interviews. My purpose in including these artists is to give you a glimpse into the thought processes and emotions that direct and motivate each of these two creative and successful photographers. In doing so, this last chapter brings us full circle from a detailed examination of tools and circumstances to a consideration of how personal vision directs technique.

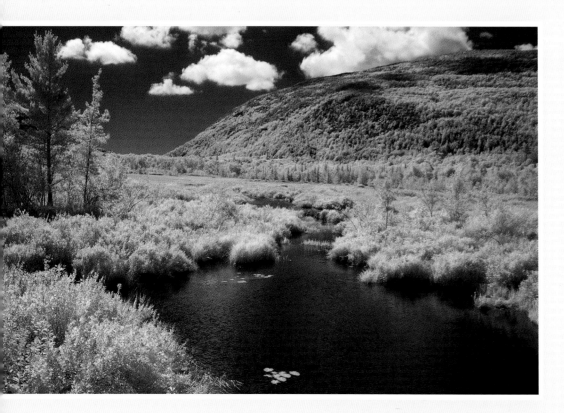

A

Monochrome Infrared Photography

One of the most unusual ways of rendering a subject in monochrome is to record that subject in infrared light. The infrared spectrum (or more correctly, the near infrared spectrum) extends beyond that of the visible light spectrum and human vision. Even though the naked eye can't see infrared light, however, certain special films and digital infrared sensors can record it. Beyond near infrared is the far infrared spectrum. Light in the far infrared spectrum makes up the thermal spectrum and is not used in pictorial photography. Characteristically, photographic capture under near infrared (IR) light drastically changes the way a scene is translated into a monochrome image. The usual conversion of colors to individual gray scale tones is quite different. This is seen in example (a) where a Macbeth Color target captured in color (on the left) has been converted to conventional monochrome black and white (in the middle) and then photographed again in IR light (on the right).

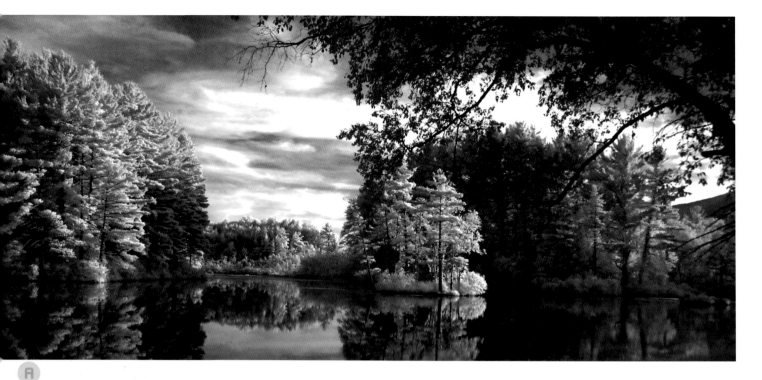

A

B

C

Characteristically, most vegetation appears light gray or white, while clear blue skies can turn anywhere from a medium gray to black. There is also a dramatic increase in contrast. All of these characteristic tendencies come together to produce a strange and otherworldly rendering of subject matter. Examples (b) through (f) are typical of what can be expected with a digital camera that has been converted to record near infrared light only. (Most digital cameras cannot record infrared light without being specially converted to do so—see pages 174 – 176.) IR photography is certainly capable of establishing mood, or giving the impression of a certain ambience, as well as rendering even the most mundane subject matter to have a uniquely dramatic look.

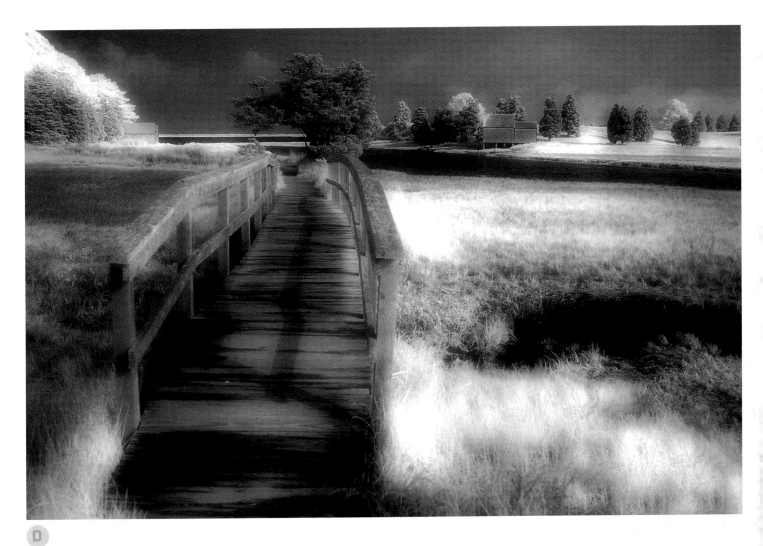

Three Approaches to Digital IR Photography

Digital photography has greatly simplified IR monochrome image making by offering three approaches. First, because the sensors in all digital cameras are sensitive to IR light, it is possible to capture subjects in this light if the visible light spectrum is blocked. Some manufacturers, however, add an IR blocking filter to their sensors. A simple test to determine if such a filter is in place is to shine the infrared beam of a television remote at the camera and take a picture. If the camera records the beam, the sensor does not have a blocking filter. Now placing a visible light-blocking filter such as an #87 or #89 filter over the lens will record what IR light is present. This was the case in example (a) taken with a 2.5-megapixel digital zoom camera on a tripod. In the case of a D-SLR with an optical viewfinder, the view of the scene will be completely blocked by these filters and the longer exposure times make the use of a tripod necessary. So this approach eliminates the inconvenience of loading and unloading film in total darkness, but still has the limitations of a blacked out viewfinder and slow exposure times. Nevertheless, the ability to obtain IR images instantly is most exciting.

A small number of digital SLR cameras use a design that transmits a video image to the viewfinder instead of the more common optical pathway. Assuming no IR blocking filter is in place, when a visible light spectrum filter is placed on the lens, the infrared picture that will be captured can be seen in the video viewfinder. Theresa Airey uses one of these cameras as noted in her section at the end of this chapter. Otherwise, when a light-blocking filter is used, the photographer has to rely on the small LCD camera screen as a representation of the captured IR image. The LCD display will show the infrared picture with some coloration. This colorcast is removed later in the computer by desaturating the image for a full-tone neutral black and white IR image, as seen in example (b).

The second and much more convenient approach to digital IR photography is to have a digital SLR camera converted so that it only records infrared light. Such custom conversions are available from a number of sources for certain SLR models (see page 190). Once converted, there is no need to use a light-blocking filter, leaving the viewfinder fully operational. These converted cameras can also make use of their full ISO range, taking pictures at shutter speeds and apertures roughly the same as with visible light and with accurate autofocus capabilities.

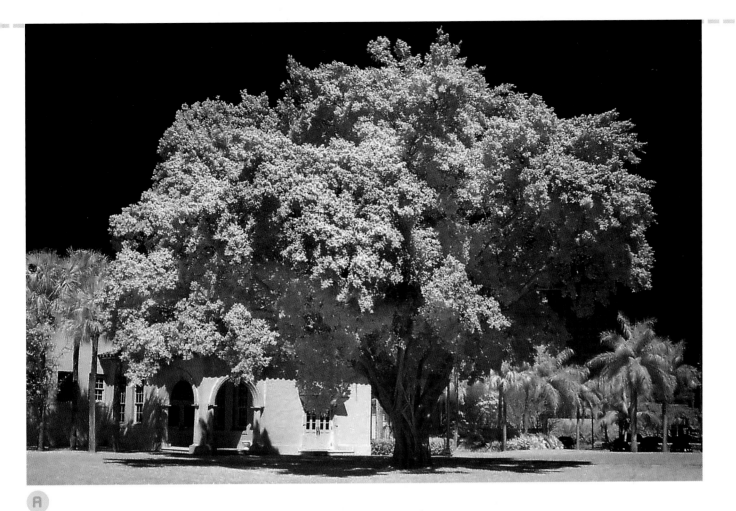

(IR light focuses at a different point than visible light. So, with an unaltered camera, adjustments have to be made in the way the lens is focused.) This means being able to photograph moving subjects at action freezing shutter speeds without the need for a tripod.

Unless stipulated otherwise, all of the remaining images referred to in this chapter were taken with various digital IR-SLR converted cameras. Just recently, the Fuji FinePix S3 Pro UVIR camera was introduced as "the world's first production Digital-SLR camera capable of taking photographs in the ultraviolet and infrared light spectrums," along with a less expensive model called the Fujifilm FinePix IS-1.

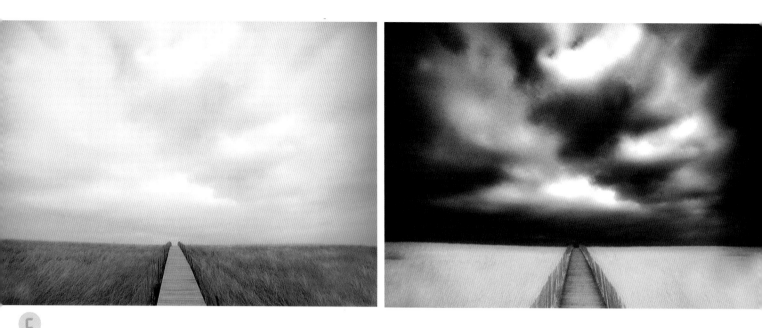

The third approach to obtaining an IR image is to use software to convert a color image to a black-and-white infrared look. This can be done either in a sophisticated general imaging software program or through the use of specialized IR plug-in programs such as the nik Color Efex Pro software "IR B&W Filter, " or the "SilverIR" filter from Silver Oxide software. Example (c) shows the before/after results of the nik Color Efex Pro software IR filter. When using a general image-processing program, the usual approach is to use the channel mixer function to mimic the way colors are converted to black and white tones in IR light, especially the rendering of green foliage as white and blue skies as black. Then a degree of softness can be added, along with some glow effects. A number of IR enthusiast websites describe these techniques in detail, along with more information about the camera conversions and use of light blocking filters (see page 190). Another great and thorough resource for those who wish to pursue digital IR photography is a Lark Books publication entitled, ("The Complete Guide to Digital Infrared Photography,") by Joe Farace.

Infrared Conditions, Exposure, and Post Processing

The best times to record infrared light with an IR sensitive camera are on bright sunny days when plenty of IR light is present. Large areas of green foliage, such as lawns and green tree leaves, are strong reflectors of IR light. The sun should be high enough to illuminate such areas, as deep shadows tend to produce a lack of detail in digital black-and-white images. Scattered clouds, however, will often help differentiate a landscape by casting shade areas, as seen in example (a). Cloudy overcast days will, on the other hand, produce muddy, low-contrast renderings.

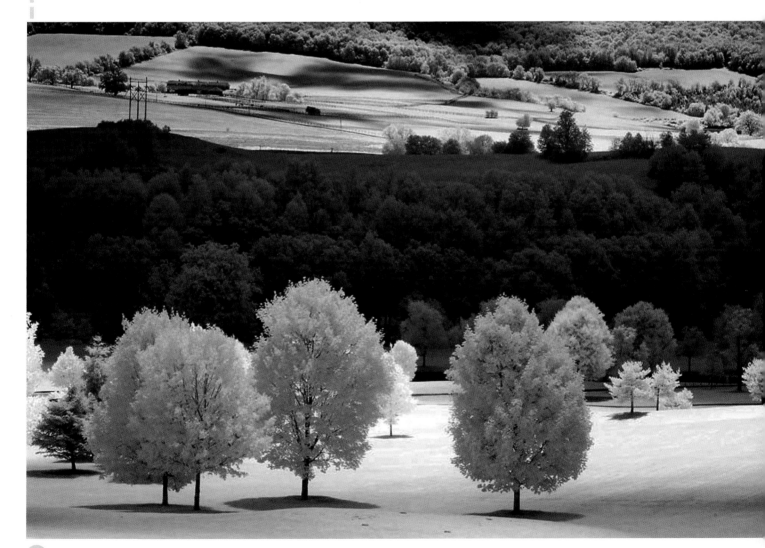

A

Most D-SLR meters will measure IR light at least "in the ballpark" for a usable exposure, but the best approach is to switch the camera to its manual exposure setting and use the camera's histogram for a rough indication of correct exposure. Bracketing will assure the best possible exposure. That is, taking exposures at the meter recommended settings, then under- and over-exposing the scene as much as 2 stops in 1/2 stop increments. Bracketing may also be useful in that two or more images can be combined in image-processing software for maximum details throughout the entire contrast range.

The most impressive IR images are ones that make full use of tonal gradation in the midtones; there should be plenty of separation between the highlight and midtone areas, and as much detail as possible in shadow areas. The idea is to build up as much of a tonal scale as possible so that more contours, shapes, and textures in the scene are disclosed. On the other hand, knowing that green foliage will come up as a strong white highlight allows for some interesting presentations. In example (b), the perspective with a moderate wide-angle lens portrays the white foliage as a snow-like high key framing around the house in the background.

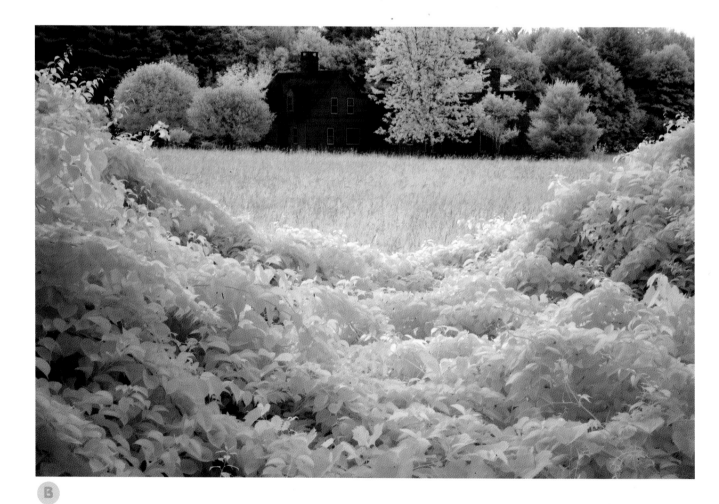

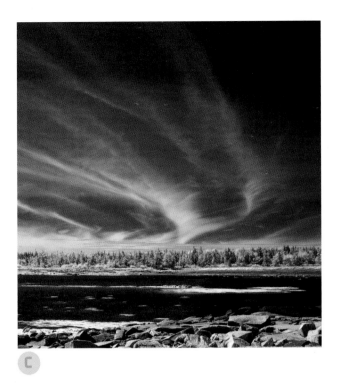

C

D

Once an IR image has been captured, the same software choices applicable to conventional black-and-white images can also be applied to IR images. For example, applying a selenium tone in PhotoKit software, as in example (c). In example (d), a soft focus effect using nik Color Efex Pro software's Classical Soft focus filter plus a sepia effect produced in Adobe Photoshop

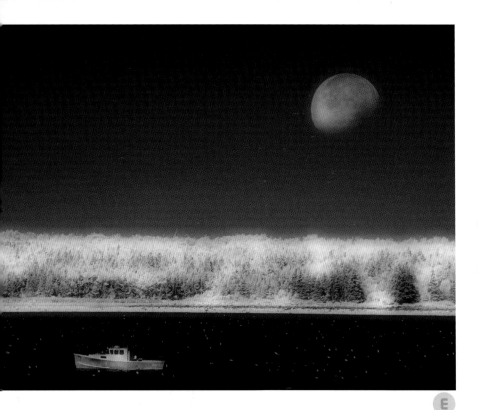

E

software was applied to a midday IR capture. In example (e), Andromeda software's Scatterlight Landscape Hallo filter was combined with a Sepia #3 toning from PhotoKit software. The landscape in example (f) received a brown tone adjustment in PhotoKit software, while the overexposed house setting in example (g) received a PhotoKit software blue toning with noise added using Adobe Photoshop software.

In summary, IR imagery is obviously very different from visible light photography. It is a form of image making that routinely transports the subject to a different world. Consequently, the photographer should approach this form of photography with an experimental mindset.

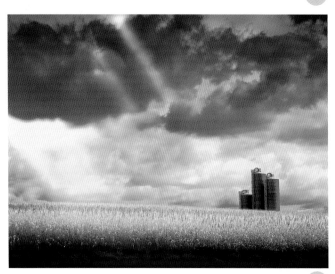

F

G

Portfolio: Exploring the Process of Personal Vision

Fine art photographer, Dan Burkholder, has been widely recognized, not only for his beautiful photographs, but also for his pioneering work in unifying traditional photographic forms with the latest digital technologies. In his award-winning book, "Making Digital Negatives for Contact Printing," Burkholder describes his method for producing enlarged digital negatives that are then used to make traditional platinum and other contact printed photographs. The results are pictures that he describes as having the "look and feel of real photographs, not like something from a graphic designer's portfolio." In his most recent work, Dan uses High Dynamic Range (HDR) imaging to create prints with hyper-real detail in all parts of the image.

Dan's photographs are found in many museum and private collections, and he has taught classes and workshops at the Art Institute of Chicago, New York's International Center of Photography, the Royal Photographic Society of Spain, and the Melbourne Royal Institute of Technology in Australia. Active with the Texas Photographic Society for many years, he is currently serving on the Advisory Board for this organization.

You can visit his website at: http://www.danburkholder.com

© O. Rufus Lovett

An Interview with Dan Burkholder

Question: You have certainly explored different forms of photographic expression in your work as a fine art photographer. Do you generally have a clear idea of what you are trying to achieve at the outset, or does the final photograph develop over several stages during which you may significantly change your original idea?

Reply: One of the few benefits of having Attention Deficit Disorder is that you are constantly aching for the next thing over the horizon. Photographically speaking, that could be as uncomplicated as a new lens or as significant as a whole new artistic project. But even were I not able to find excuses in ADD behavior, I like to think I'd always be pushing my personal artistic envelope, never content with repeating myself, and always seeking artistic growth. The five prints I've included here illustrate my moving from classical platinum/palladium printing (from digital negatives) to embracing the new digital color technologies and, finally, to a project that has a voice through High Dynamic Range techniques.

With unabashed humility, I always state that my photographic goals are exceedingly unadorned; I am looking for visual intrigue and beauty. If either of those gets in front of my camera, I'll do whatever it takes to get it on chip. Admittedly, I am a formalist when it comes to composition. Alas, there is much modern photography that simply lacks any hint as to how the eye should move about the frame.

For me, humor and art are very similar. A person smarter than I said, "Humor is the unexpected copulation of ideas." If we put things together in a certain (and sometimes absurd) way, the result is that laughter is elicited. Art is like that too. We're trying to see things in new and different ways. That is, unless we're content with "what sells" and "what looks good over the sofa," we're trying to establish new and novel and—dare I say—intriguing ways to combine and represent the visual elements in our surroundings. Those visual tickles are delightful when they work. And finally, remember that of all the jobs to which photography can be assigned (journalism, architecture, scientific documentation, fashion, portraiture, etc.), my little corner—fine art—affords the most leeway in interpretation and final rendering of the subject matter. In case you hadn't guessed, that's a proverbial double-edged sword.

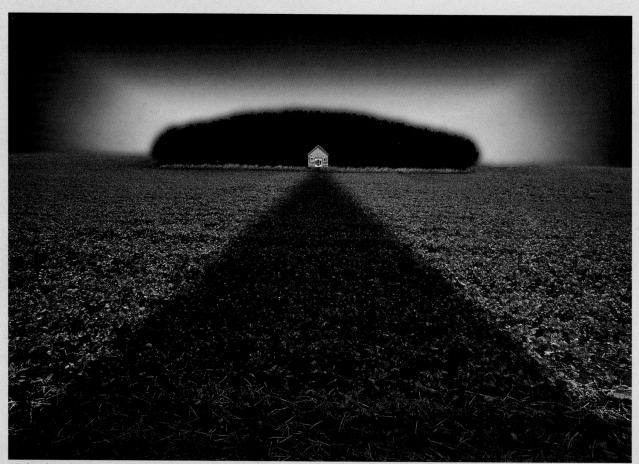

"School and Tress, Scotland"

I photographed the group of trees in "School and Trees, Scotland" while in Scotland in 1986. A recurring compositional theme in my work is a formal symmetry that, to me, feels remarkably normal and comfortable. Though I liked the group of trees by themselves, they never made for a successful image. About six years later I photographed the one-room schoolhouse in which Lyndon B. Johnson attended his early grades. I don't know what triggered the idea to put that schoolhouse with the Scotland trees but the final image possesses a compositional boldness and rich tonality that I love, both in my work and in others'. The final print is a hand-coated platinum/palladium print.

"Turtle in Church, Alice, Texas"

I like to think "Turtle in Church, Alice, Texas" reveals my sense of the whimsical while at the same time showcasing my penchant for the composite photograph. I assembled this image from three separate negatives shot on three consecutive days back in 1994 when Photoshop software didn't even have Layers. Today, it's hard to imagine working without the benefit of Layers, but in those primitive times we worked around the limitations just as wet plate photographers worked around their restrictions in the 19th century. The 12 x 18-inch (30.48 x 45.72-cm) platinum/palladium print has become a signature piece in my portfolio.

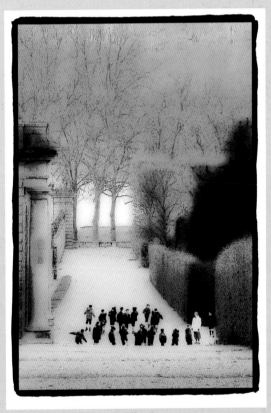

"Schoolchildren, Versailles"

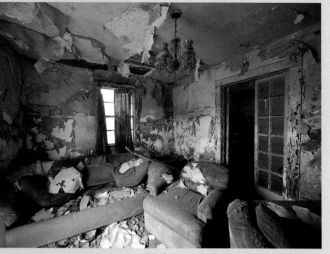

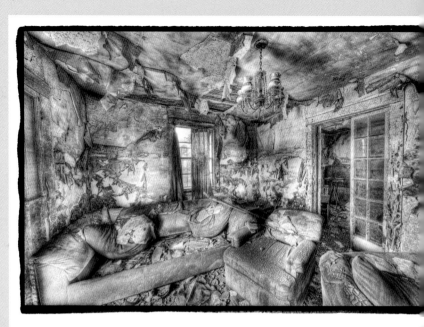

"Pink Living Room, New Orleans": Original single exposure capture (above); HDR result from merging multiple exposures of the scene (right).

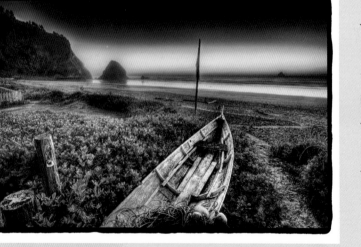

"Boat and Moon, Oregon"

I'm not known as a people photographer, but when they do appear, they serve as visual props and clues more than as primary subjects. The children in "Schoolchildren, Versailles" capture a playfulness that helps counter the rigid composition of the trees and buildings.

Though I've never considered myself a project photographer, the New Orleans series sort of found me instead of my finding it. "Pink Living Room, New Orleans" is one of my favorites. I try to lure the viewer into the image with design, color, and composition where they are then shocked with what they are really seeing in the clutter and destruction. The most common response—and the one I am hoping for—is, "I didn't realize it was that bad in New Orleans."

Jerry Uelsmann once said, "When the only tool you have is a hammer, you treat everything like a nail." I'm pretty much following that logic at the moment as I try to learn how to best use High Dynamic Range imaging in my own photography. The "Boat and Moon, Oregon" image was made from a series of bracketed images that let me capture the full range of tones from the deepest shadow to the hottest highlight.

© *Theresa Airey*

Portfolio: The Photography of Theresa Airey

Theresa Airey holds an MFA in Photography and Fine Art and has a well-earned reputation for a style that combines skills in fine art methods and computer technology with photography. Her latest projects have included the restoration of 150 glass-plate and nitrate-based negatives taken of turn-of-the-century Bermuda. Theresa is presently working on her second book about old Bermuda, this time working with vintage negatives and re-photographing the same location 100 years later.

Theresa has taught photography at the University of Maryland, Towson State University, and the Maryland Institute College of Art. She also conducts private workshops in her studio in Monkton, Maryland and around the globe. She is a regular lecturer for professional photographic expos and has had many one-woman exhibits throughout the United States and abroad.

An Interview with Theresa Airey

Question: You are best known for "crossing the boundaries" between traditional printmaking, painting, drawing, digital art, and photography to produce original photographic images. Do you purposely photograph certain subjects with a firm concept of the final image, or is this something that develops later in the computer?

Reply: I have always considered myself more of an image-maker than a photographer. For me, the first step is taking the photograph in the field, which I enjoy immensely. The second step, which is the most exciting part for me, is "making" a photograph. I like to create an image by combining my technical skills with my feeling about the subject. The result is a photograph seen through my mind's eye.

Most of this interpretive work is done after taking the shot. However, once in a while, I do see something while photographing that I know will make a great hand-colored image or that I can use in a collage. What I find key to a successful body of work is to process my digital

"Vestal Virgin"

files immediately after photographing. In this way, the feelings and emotions that were involved in the image taking are still fresh in my mind when I work on the image making. The four images shown here were selected because they are each quite different.

I took the photograph of the nude in France while teaching a workshop. There was something very evocative about the way the model draped the shawl around her head. I remember thinking at that time "she looks like she is in church." Later, while in Paris, I photographed an ancient piece of religious cloth in a glass case. When printing the nude, the image of the ancient cloth came into my head and I layered it with the nude in Photoshop software. The image then felt right. It felt complete.

"People of Peru"

Peru was colorful and magical; the people were kind and spiritual. I knew that it would be impossible to translate such a barrage of impressions into one image, so I physically collaged together photographs that I liked, using paints and exotic papers to add dimension and complexity. I thought that the use of cheesecloth would create a "cob-web" effect to emphasize the ancient culture that I had experienced and also to intimate a "peeking into" experience. This was how I felt. I was an outsider looking in.

"Roman God"

"Ancient Echoes"

I visited Pompeii and photographed the excavated ruins of the ancient city. I was amazed at the clarity and color of the frescos still remaining on the walls. I began to collage images together, both inkjet prints and transfers, adding paint and bits of old papers in order to give it a cohesive feeling. I then realized that the piece was too colorful. Somehow the antiquity of the place was lost in my translation, so I de-saturated the colors in order to emphasize the passage of time and printed the images on a handmade natural colored paper that looked like papyrus. After doing this, I felt that the drama and feeling of ancient history had seeped back into the image.

I started this piece with no clear direction. I had images of masks that I had taken, leaves that I had collected, and various interesting collectibles. Assembling the image was very much like diving into a stream of consciousness. As I worked, the piece took on a life of its own. I felt rather than planned what was happening. I used paints, stamps, papers—I even drew on it. When I felt it was finished, I stood back and realized what it said to me. It was full of feelings and echoes from within me, hence the name "Ancient Echoes."

When I am shooting with infrared light (both film and digital), I am "seeing" a different world. This type of photography moves beyond the world of the visible to catch and portray the invisible, thereby giving me a deep appreciation of the complex world around me. With film, it was always very tricky to capture infrared, but I learned to "think" in infrared in those days and could actually see the infrared in my mind.

Today with digital cameras, I am able to actually see the infrared light-waves thru the viewfinder. The camera that I use that allows this is Minolta's old DiMage 7. It is a creative boost to be able to actually "see" in another realm of reality. Recently, I had my Canon D60 camera converted to cap-

ture infrared, but it is not the same. You are looking through the viewfinder and seeing the landscape in color and only when you look at the LCD screen can you see what you have captured, and that is not in black and white. For the most part, the subject is captured in either red and black or a cyan blue and brown and must be converted to a black-and-white file in the computer. However, I do sometimes like the cyan blue and brown rendition, as it imparts a very surreal feeling. But then again, it is a very different feeling and, for me, it interferes with the creative process when trying to capture the drama of pure black and white infrared.

I also love to hand color prints and infrared images facilitate this technique, as the prints are lighter with less midtones than a straight black-and-white print. Usually, I make the decision to hand color a print after it is made, when the print "feels" like it should be colored. Seldom do I take a shot and think, "this will look great hand colored," but it has happened.

The mystery and magic of infrared carries me beyond the literal perspective of my eyes into the limitless vision of my mind's eye. I find infrared photographs can be very haunting, dramatic, surreal and unworldly as compared to the world we know with our eyes. I feel energized and inspired when I photograph with infrared. It is a great feeling.

One thing that I have learned over the years is that if I am going to shoot in infrared and get a great image—not just a good image—I cannot shoot both color and infrared at the same time. My mindset must be focused on infrared and then I can enter into that realm of magic and mystery. "The Wishing Well" was taken at my favorite garden in Bermuda, which I think is very beautiful and dream-like. This shot captures the magic and fantasy of the garden.

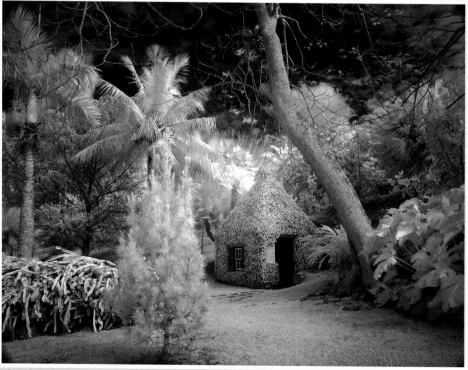

"Coral Ledge"

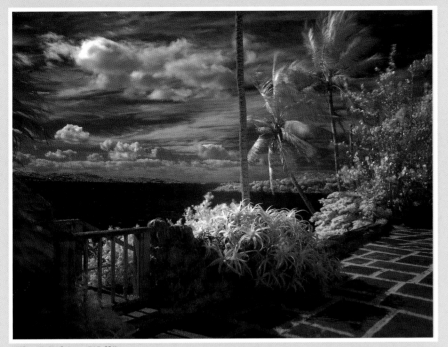

"The Wishing Well"

In the "Coral Ledge" image, I was capturing infrared on a blustery overcast stormy day where the sunlight would come out for just a few moments and disappear quickly behind the rapidly changing clouds. However, when the sun did come out, the light was exquisite and it brilliantly lighted the foliage against a dark dramatic sky. An #87 deep red filter emphasized the cloud formations and captured the foliage in all its infrared glory, conveying the feeling of drama and enchantment that I was experiencing.

I have always thought that Banyan trees were fascinating. They have always looked to me as if they could walk with their long ascending roots. On this particular day, I was walking through a thick forest of Banyans and I noticed a circle of light on the forest floor. When I looked up, the myriad of trunks and roots looked as if they were holding up the thick canopy of leaves through which only a small stream of light was able to enter and cast its presence in the dark woods. I think that this infrared capture of the scene illustrates the mystical and magical qualities of the Banyan woodlands.

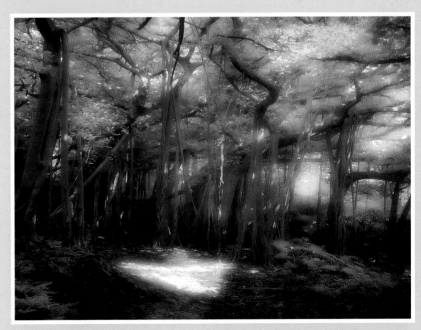

"Magic Banyan Trees"

Appendix

Contributing Photographers

Theresa Airey (Chapter 8) E-mail: <Aireyt@aol.com>
Dan Burkholder (Chapter 8) Website: <http://danburkholder.com>
Donnette Largay (Chapter 6) Website: <http://www.donnettelargay.com>
Peter Peirce (Chapter 4) Website: <http://www.peterpeirce.com>
Natalia Stork (Chapter 3)

Software Links

Alien Skin (Exposure, Film Grain) <http://www.alienskin.com>
Andromeda (Scatterlight) <http://www.andromeda.com>
Auto FX (Mystical Lighting, Dream Suite) <http://www.autofx.com>
Grasshopper (Image Align) <http://www.grasshopperonline.com>
Imagenomic (Noiseware noise reduction software) <http://www.imagenomic.com>
Lensbabies <http://www.lensbabies.com>
Neat Image (noise reduction software) <http://www.neatimage.com>
nik Multimedia (Color Eflex Pro, Dfine) <http://www.niksoftware.com>
Noise Ninja (noise reduction software) <http://www.picturecode.com>
Pixel Genius (PhotoKit) <http://www.pixelgenius.com>
PowerRetouch (SoftFilter) <http://www.powerretouche.com>
Visual Infinity (Grain Surgery) < http://www.visinf.com>

Digital Panoramic Photography

Arcsoft Panorama Maker <http://www.arcsoft.com>
International Association of Panoramic Photography <http://www.panphoto.com>
PanaVue ImageAssembler <http://www.panavue.com>
Panoramic Factory <http://www.panoramafactory.com>
Panorama Photo Software 360 <http://360dof.com>
Realviz Stitcher <http://stitcher.realviz.com>

Additional information on specialized tripod and panoramic heads as well as other panoramic hardware and techniques can be found with an Internet search for "Digital Panoramic Photography" or "Panoramic Stitching Software."

Digital Infrared Photography

IRDigital <http://www.irdigital.net>
LP Net <http://www.maxmax.com>
Jim Chen Photography <http://www.jimchenphoto.com>
Life PixeL <http://www.lifepixel.com>
Khromagery <http://khromagery.com>

An Internet search for "Black and White Infrared Photography" will produce more information on camera conversions and digital IR techniques.

Index